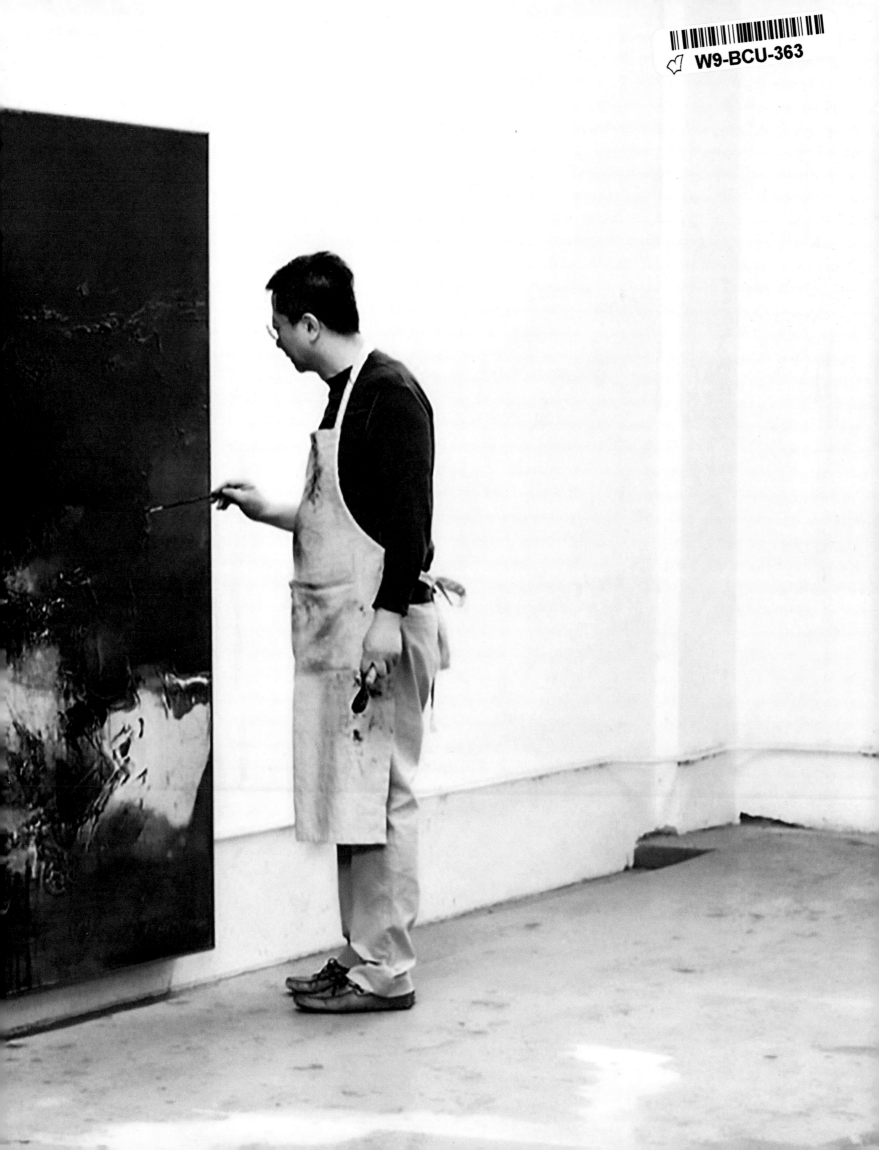

# WANG YAN CHENG

# 王　　衍　　成

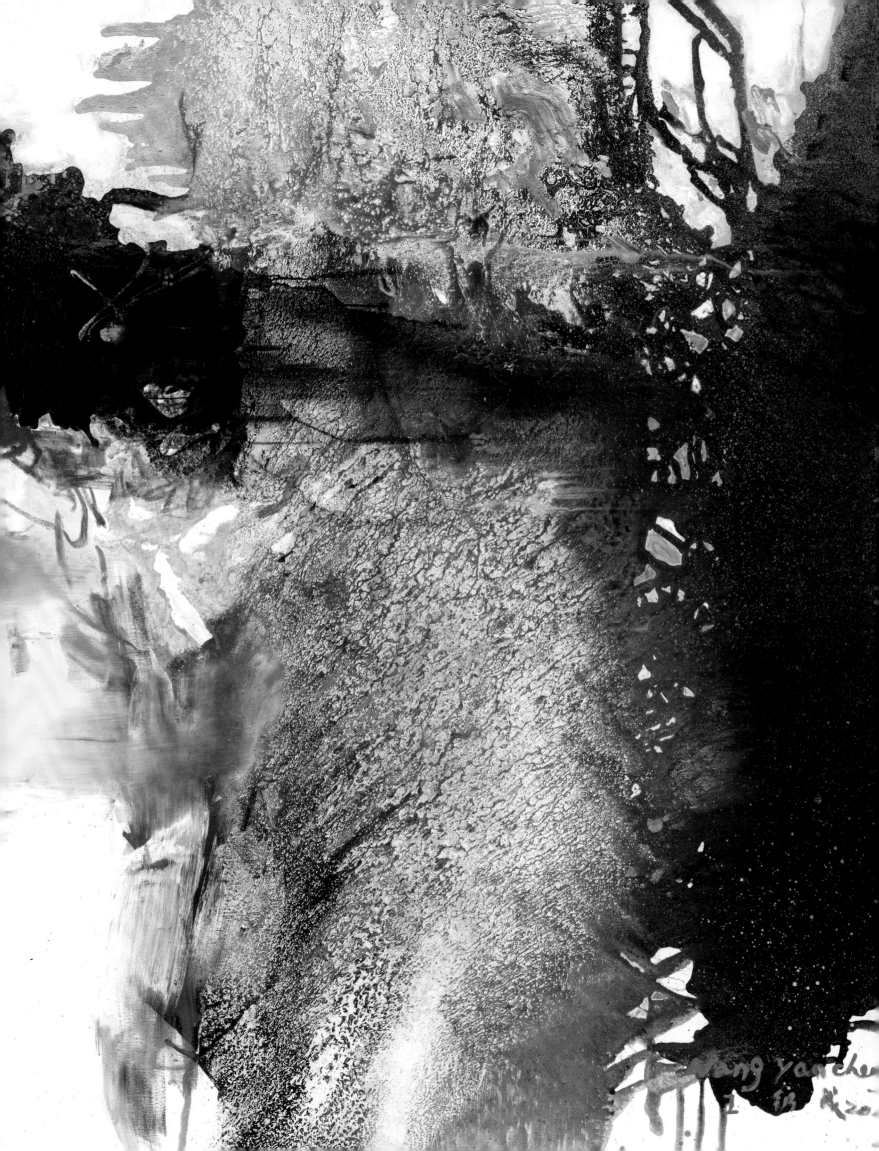

# WANG YAN CHENG

王　　衍　　成

WITH TEXTS BY

**Dominique de Villepin**
**Gabriele Simongini**

ACQUAVELLA

This publication accompanies the exhibition

# WANG YAN CHENG
## 王　衍　成

ON VIEW
### September 11 – October 18, 2019

**ACQUAVELLA GALLERIES**
18 East Seventy-Ninth Street, New York, NY 10075
www.acquavellagalleries.com

LIBRARY OF CONGRESS CONTROL NUMBER
2019909373

ISBN
978-0-9981156-6-5

DESIGN
HvADesign, New York

PRINTING
Phoenix Lithographing, Philadelphia, PA

Cover
Detail of *Untitled (Triptych)*, 2019
oil on canvas in three panels
82 5/8 × 307 inches (210 × 780 cm), each panel 82 5/8 × 102 inches (210 × 260 cm)

Frontispiece
Detail of *Untitled*, 2019
oil on canvas in three panels
102 × 82 5/8 inches (260 × 210 cm)

Endpapers
Photos of Wang Yan Cheng in his Beijing studio, 2019.

Contents

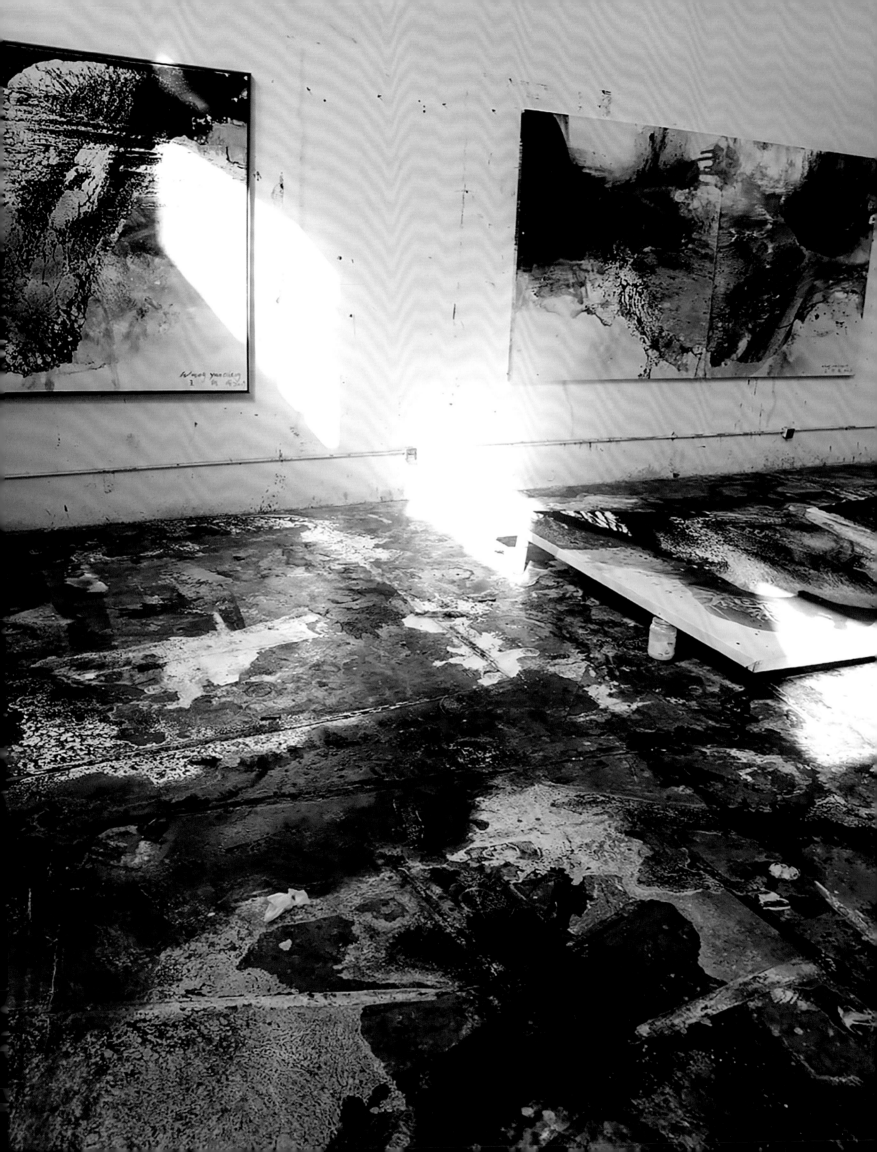

# INTRODUCTION

We are delighted to present this exhibition of recent paintings by Wang Yan Cheng. Though the artist has exhibited widely in Europe and China, this is the first show dedicated to his work in the United States.

Born in 1960 in the People's Republic of China, Wang learned traditional Chinese calligraphy through his father and studied figurative painting in China before traveling to France to study European painting in 1989. He discovered a profound affinity between the expressive abstraction of twentieth century Western art and traditional Chinese painting, and soon developed his own distinct language of lyrical abstraction fusing Eastern and Western influences. Today he works in both Europe and China, maintaining studios in Beijing and Paris.

For their work on the exhibition, we would like to acknowledge the team at the gallery including John Andrew, Anna Carroll, Kristen Clevenson, Emily Crowley, Joyce Liu, and Eric Theriault. Our gratitude also goes to Keith Harrington at PhoenixLitho and Henk van Assen at HvADesign for their work on the catalogue. Above all, we would like to thank the artist for sharing his beautiful paintings with us.

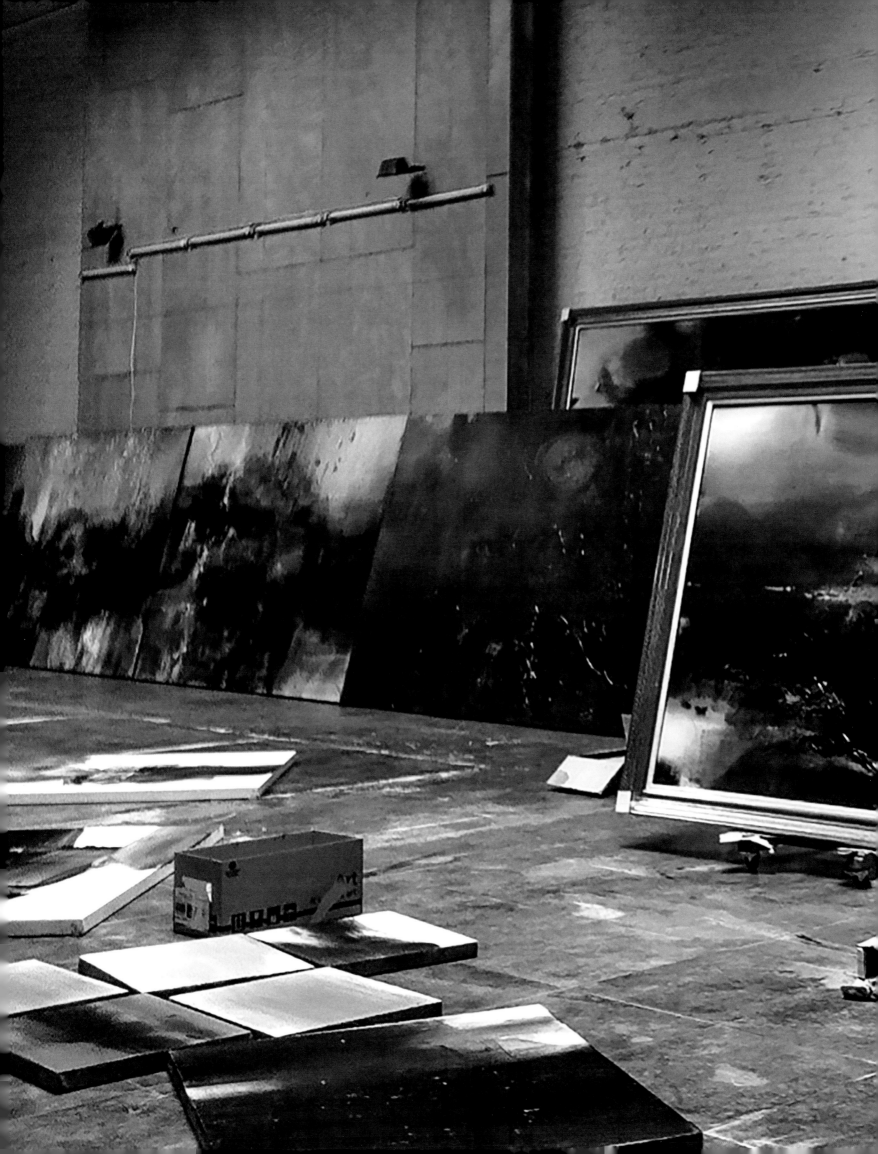

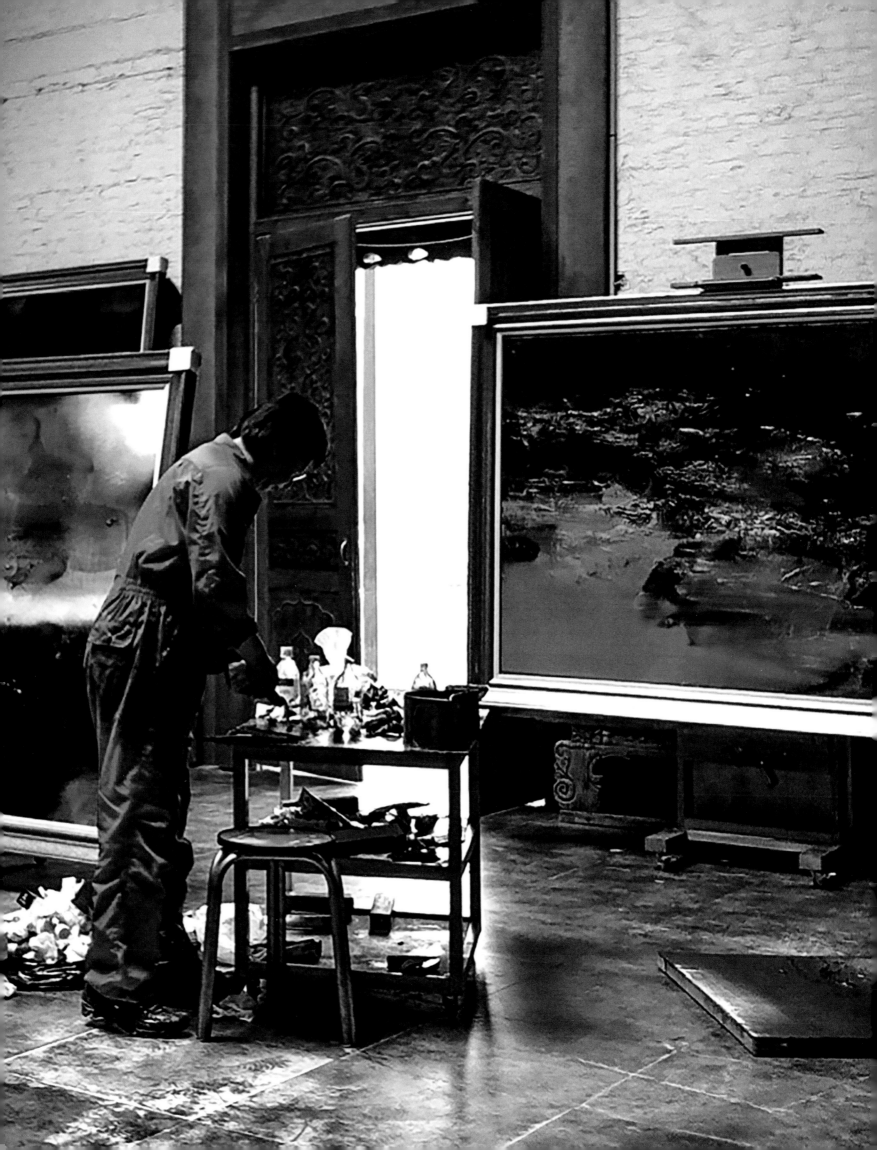

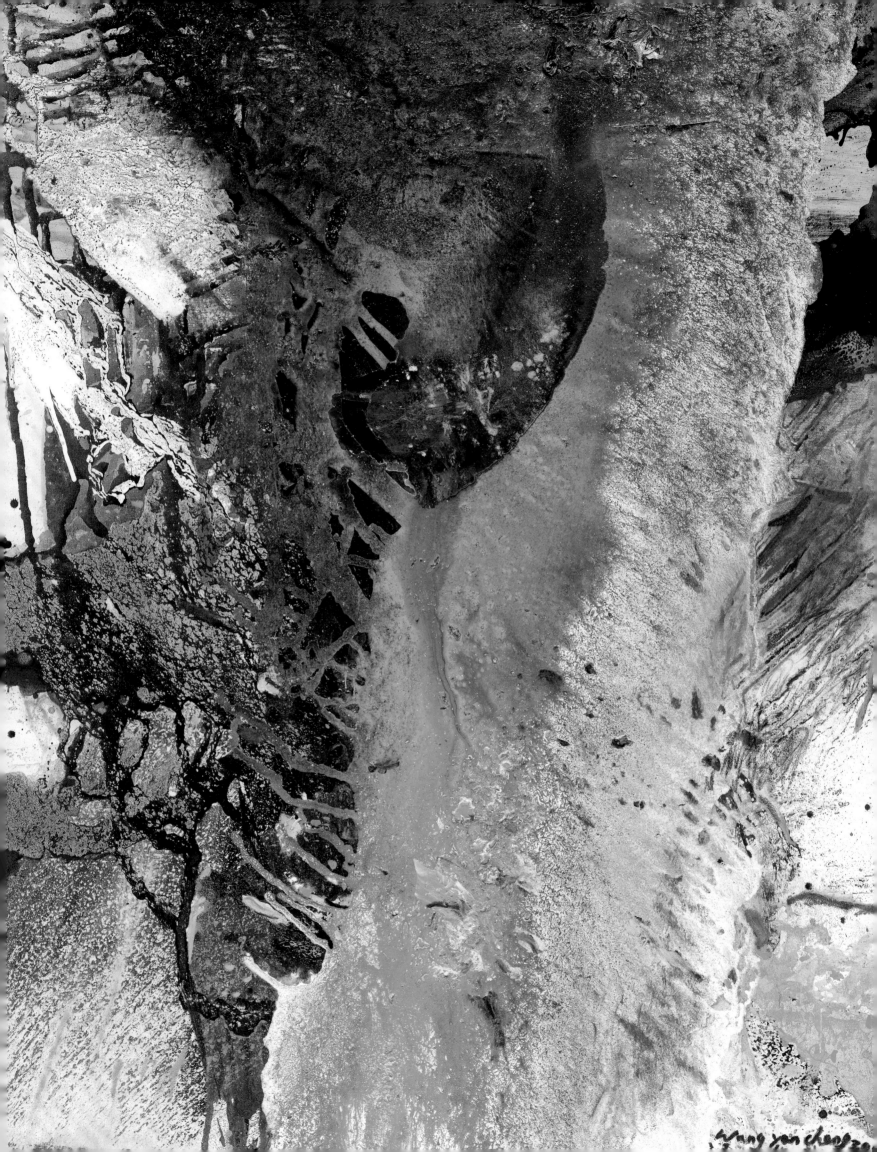

# WANG YAN CHENG
## THROUGH THE LOOKING-GLASS

## Dominique de Villepin

Walking in the sun between the puddles; strolling between sand and pebbles; leaving one's heart to travel on paper boats … Wang Yan Cheng, there are tastes of childhood in my friend's work, there is the freedom of the one who is led by his imagination, transcending the rules without dismissing the opportunity of a genuflection to the Ancients. Time adds many layers over and over, leaving light to filter through, coming from afar. Here, material still quivering, there light iridesces slashing the canvas like a mocking spike.

The concern of the artist is for the future. With his frontlight, he walks, searching the maze of sky and earth till he reaches the most distant edges where the border dissolves, where the rocks are pulverized, as the clouds harden. Mystery is summoned, but without anxiety. Only the excitement of the journey remains. At this moment, no need either for reconciliation. The pages of day and night turn for a serene Odyssey travel. He takes note of every step, confident. Tomorrow is his ally, because he trusts his predecessors. He knows he is not alone, pulling with him all those who, left by the wayside, had lost hope.

His generous work enlarges, enriches, pulls, lingers, waiting for the others, carries in its herbarium signs, remains, species. He gets his revenge, he will still be there, no doubt, when the hour of salvation comes. We glimpse, through the looking-glass of the canvas, physical and mental energies mingling in an explosive harmony, a man's destiny, the forces of nature, in the end it all comes down to these fundamental condensations flowing between the visible and invisible worlds. Wang Yan Cheng knows better than any other how to summon these remote energies, catch them in the air and tie them to the canvas, nailed to the stretcher. In these titanic eruptions, the paintings precipitate where the

WANG YAN CHENG  |  *Untitled* [detail], 2019  |  oil on canvas  |  102 × 82 5/8 inches (260 × 210 cm)

colors amalgamate, in a gushing of laces, barely more than matter carved by the void, till absence, as if it were getting to the very source of movement. As if hailed by fire, the paintings seem to give evidence of a stormy trip, at the end of which looms freedom.

But where does this luck come from? We have to follow his word which hesitates when his stroke does not. The man gladly addresses the silence inhabited by those who brought themselves to depart. Wang Yan Cheng is a master of humility, able by demand, by inner necessity, by faith in painting, to set off with his pilgrim's staff, to leave and deeply root himself in a new country, France, able, even as an already renowned artist, to submit to new training, able to finally understand that painting must become the physical, muscular, carnal confrontation of the artist with the canvas. He paints with his whole body to tear away from the surface the quiver of the being and draw forth feelings.

This humility, this quiet wisdom that dwells in him, drives him to fully offer himself to painting. In an age that lies to itself by imagining an authenticity given in advance and where it would be enough just to remain yourself, against all odds, he knows that one has to accept to lose himself before becoming his true self. That the soul is at the end of the quest, not at the beginning. His first name in Mandarin means change, evolution. He remained faithful to this fairy word and never stopped, in his technique, in his colors, and above all in himself, to change and move forward. He went through much training, walked through many landscapes, then a few passes farther, he found his own path, ready to face solitude as well as encounters. Wang Yan Cheng knows how, on the way, to make himself available to the Other.

To leave, yes, to leave! When others keep their eyes on the acknowledgement of the public, complying with the carousel of honors. But here, no reward, only the blessing of the Grand Tour, after those who opened up the way for him. Wang Yan Cheng does not deny his debts, he goes on along his path entirely absorbed in creating destructuration. What was only yesterday left of the subject, slowly goes on fading. Here come winds, dissolution, fragmentation in an interlacing of sharp wavy shapes. The First man can come closer, he will not feel disoriented. He has come full circle, the baton has been passed.

Let's remember the long way he came. For many years, the artist has humbly worked in his den, layer after layer. Brimming with vitality, he did not feel any fear when multiplying the mixtures, thickenings and overlappings. Reality, under the burden of labor, dissolved little by little in the background. Only remain the sails superposed like so many memories. The quest goes on. Spotlight on the mystery of the quiver, of the disentanglement where void invades more and more his large triptychs. Darkness overpowers everything even if at times color bursts in places over the canvas. Witty patches twist over the wax deposited in thin films. The victory of the void echoes in the distance. We are now living through the after-disaster. Therefore, more than ever, he summons, right in the heart of his work, the movement, that alone has the strength to forcefully free a new breath, sweeping away

the plagues and curses without forgetting to appeal to the hourglass leaving day after day its own imprint. In doing so he returns to the ancient paintings of his country. In a same stroke both come true, the creation and the revelation of the brush that dashes over the surface of the paper like the eye follows the ceremonial discovery of the scroll on anniversary days. Each painting keeps its own internal clock. It remembers ordeals it faced, creatures and traveled routes. But harmony which once reigned supreme is no longer the ultimate meaning of the quest, nor is it the composition, that has been for long at the forefront of the attention of the artist, that remained the essential rule. What for many years has been his daily concern, to restore an order through the choice of colors and shapes, no longer is his primary duty. There is reverie in his paintings, a joy to divert his gaze, come out of himself, leave his body for the pure color, paint the other face of the clouds. Wang Yan Cheng has come to the continent of the unreal from where he brought back colors, glittering like gemstones dissolved in the wall of the canvas. Colors from the outer-world that defy not only presentation but raise the longing for a different world, more complete, brighter, more exciting. We realize how dull our world is and how blind we remain to the highest reality.

Through the movement, the wide and passionate gesture of the artist, a new quest emerges. And, when he might be afraid of being accused of doing too much, today he takes the accepted risk of not doing enough. He goes one step further. He frees himself from his chosen companions, Chu Teh-Chun, Zao Wou-Ki, Gerhard Richter but also Cy Twombly, one for his dancing colors, the other one for his tormented struggles, the third one for his visual disorders and the last one for his witty line sets. He has built a new alliance with elemental forces: the earth, the wind, the water, the fire composing a surprising team. Above all, he refuses to shut his eyes, he faces the present when everything around us falls apart under the repeated assaults of a cursed globalization. A new disaster arises from the depths of the earth, once more nurtured by the very hands of man, with its trail of torments, quakes and epidemics that splash, tear and whip the canvas. In the very heart of the disaster, he draws his loot of gems and spices torn away from destruction and given as evidence, similar to trophies. Violence imposes itself, necessary in its sacrificial and purifying surge, on the altar of truth. Because this is the real object of the quest and it generates risks, abandon, the obligation of deprivation and asceticism. The sails that, only yesterday, were still moving, in the heart of the work, disclosing while hiding, currently appear much sharper. They sting reality, free the images to open the doors of the invisible. Freer, the artist can travel farther. To reach harmony, he always felt the urge to add a patch of color here, a layer there, until finding from all the times compressed and juxtaposed, the right time, tamed by the schemes of colors, shapes and matter. In his painting, the promised land appeared, full of juice, fruit, living species, making it not only more inhabitable but also more desirable. The disaster came this way, the future moved away, more illegible, more elusive and for Wang Yan Cheng the struggle has changed. To say, to name, to juxtapose, is no longer enough. Figuration faded, it has been left with no figure. Abstraction itself is not enough, facing the multiplication of places and numbers. Its weapons are blunt. Everything that has been acquired, ascertained, adored, must be put at stake. New weapons must be furbished. This is time for fragments, for explosion,

for eruption, for the original breath that one has to recover to restore life. Along the way, even if he refuses to indulge in wiles, he does not disdain the complicity of a wink, the derision of coloring, in multiple spots reminiscent of an ancient order. Gone is the memory of paintings quietly hanging up on the walls of Museums.

We can be sure that, for the artist, it is only a transition, but a necessary one in the metamorphosis he took upon himself. A very cruel truth when it imposes to the one who wants to reach it to advance as close as possible to the frontline, where painting and History become inseparable. The gesture of painting itself becomes part of an adventure, becomes Revolution.

However, the thread we follow, as viewers, from one exhibition to the other, remains alive, faithful to the land where the painter trained, to the awakening of Shandong landscapes. To the original green and blue, the ochre, black and brown tones join, that also belong to the hollows of the mountains and the embayments of the coasts of the East China Sea. On the walls of the canvas, he goes on collecting, always with the same humility, the signs and traces, all the proofs of the visible, but now, he does not exclude the chaos, the vertigo of the whirlwinds and of the voids. Then the whole canvas enlivened by movement, tormented by a challenge, reveals both the vast flow of the powers consuming the stage and the tiny details that suggest vesicles, filaments and lineaments as under the sharp eyes of a doctor or a scientist. The eye travels effortlessly from the cellular churning to the astral swirl.

Here the immense joins the infinitely small, seized together by the hand of the artist. In small formats, it is the talent and patience of the miniaturist that express themselves. The paintings are complete, consistent, strong, compact like lockets where we would try to keep memories, the evidence of a world that we know will soon no longer exist. Maybe in this intimate memory, behind the veils, there is the other side of the childhood landscapes? Landscapes on the verge of the unreachable: misty sunsets, bright and green slopes of a land inhabited by the spirit, haunted by humanity, steeped in centuries. In this memory there is China, there is the whole man.

Concerning the shapes, we will not be surprised that the adventure takes us much further than what our eyes can capture, further than abstraction too, in an inverse motion, joining the real. Wang Yan Cheng's hand releases a new freedom to see, through new prisms and lenses.

Desire remains alive on the great stage of the painting. Something remains that escapes capture and leaves us outside, on the brink of a story that, the painter knows it, is not over, in the expectation of another revelation.

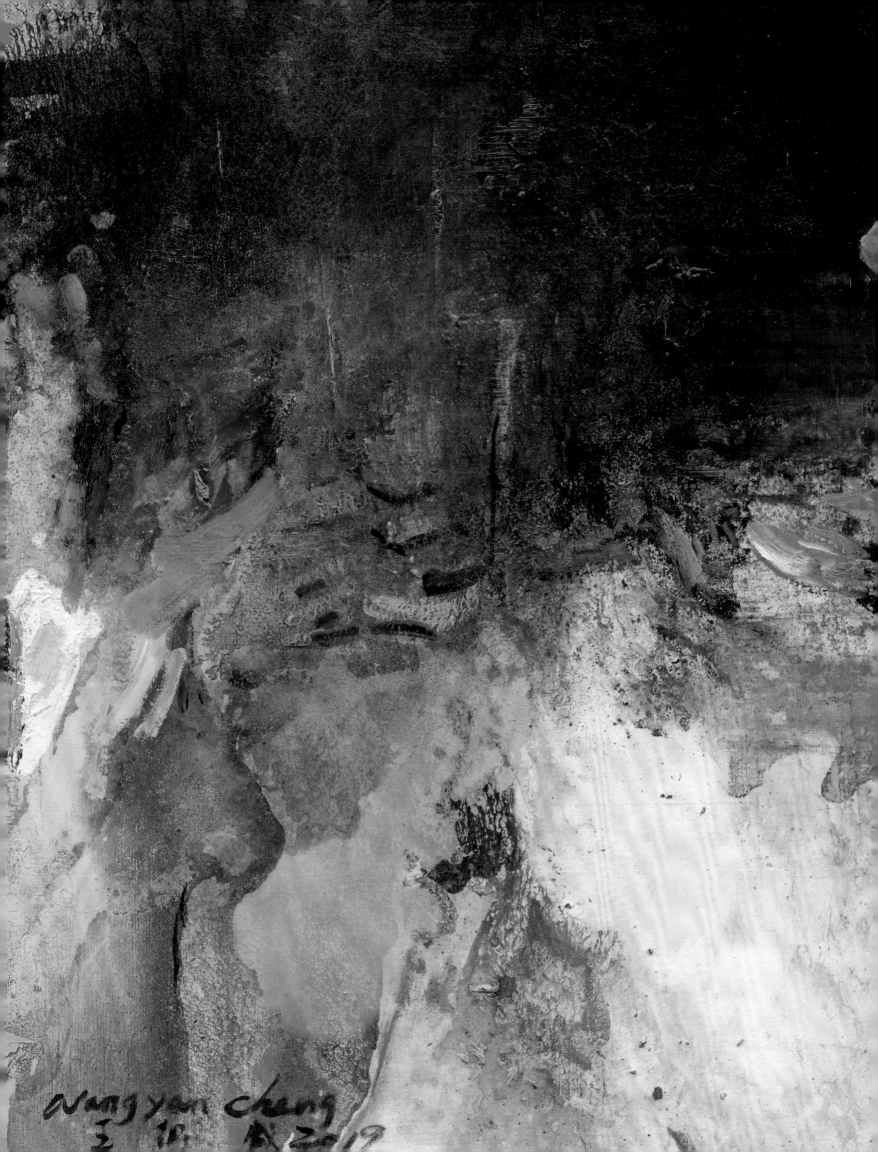

# WANG YAN CHENG
## DE L'AUTRE CÔTÉ DU MIROIR

### Dominique de Villepin

Marcher au soleil entre les flaques d'eau; voyager entre sable et galet; laisser son cœur s'aventurer au dos de bateaux de papier... Il y a de l'enfance chez mon ami Wang Yan Cheng, il y a la liberté de celui qui se laisse porter par son imagination, s'affranchissant des règles tout en ne dédaignant pas la génuflexion vis-à-vis des Anciens. Le temps s'inscrit en couches nombreuses, laissant filtrer une lumière qui vient de loin. Ici, des matières encore frémissantes, là des irisations légères qui lacèrent la toile d'une pointe moqueuse.

Le souci du peintre est celui de l'avenir. Il avance armé de sa lampe frontale, fouille le labyrinthe du ciel et de la terre jusqu'aux marches les plus lointaines où la frontière se dissout, la roche se pulvérise, tandis que les nuages se durcissent. Le mystère est convoqué, mais point d'angoisse. Seule l'excitation du voyage. Nul besoin non plus à cet instant de réconciliation. Les pages du jour et de la nuit se tournent pour une Odyssée sereine. Il en note les étapes, sûr de son fait. Demain est son allié, car il fait confiance à ceux qui l'ont précédé. Il sait qu'il n'est pas seul, entraînant avec lui tous ceux qui, oubliés sur le bord du chemin, perdaient espoir.

Son œuvre généreuse s'élargit, s'enrichit, qui entraîne, s'attarde pour chacun, charrie en son herbier signes, vestiges, espèces. Il tient sa revanche, il sera encore là, soyons-en sûrs, à l'heure de la délivrance. Nous entrevoyons, de l'autre côté du miroir de la toile, des énergies psychiques et physiques mêlées dans une harmonie explosive, le destin d'un homme, les forces de la nature, tout revient, en fin de compte, à ces condensations principielles, circulant entre les mondes visible et invisible. Wang Yan

WANG YAN CHENG  |  *Untitled* [detail], 2019  |  oil on canvas  |  36 1/4 × 28 3/4 inches (92 × 73 cm)

Cheng sait mieux qu'aucun autre invoquer ces énergies lointaines, les saisir au vol et les attacher à la toile, clouées au cadre. Dans ces éruptions titanesques, les tableaux précipitent là où s'amalgament les couleurs, dans un jaillissement de dentelles, à peine plus que de la matière creusée par le vide, jusqu'à l'inexistence, comme s'il remontait à la source même du mouvement. Comme grêlés de feu, les tableaux semblent témoins d'un voyage houleux, au bout duquel point la liberté.

Mais d'où lui vient cette chance? Il faut suivre sa parole qui hésite quand son trait, lui, ne doute pas. L'homme tutoie volontiers le silence qu'habitent ceux qui se sont résolus au départ. Wang Yan Cheng est un maître de l'humilité, capable par exigence, par nécessité intérieure, par foi dans la peinture, de prendre le bâton de pèlerin, de partir et de planter ses racines dans un nouveau pays la France; capable, artiste déjà reconnu, de se soumettre à de nouveaux apprentissages; capable enfin de saisir que la peinture doit aller jusqu'au face à face physique, musculaire, charnel, du peintre et de la toile. Il peint de tout son corps pour arracher à la surface le frémissement de l'être et faire éclore des sentiments.

Cette humilité, cette sagesse tranquille qui l'habite, le conduit à s'offrir tout entier à la peinture. Dans un âge qui se ment en imaginant l'authenticité donnée par avance et où il suffirait, envers et contre tout, de rester soi-même, il sait qu'il faut accepter de se perdre pour devenir soi-même. Que l'âme est au bout de la quête, pas à son point de départ. Son prénom, en mandarin, signifie changement, évolution. Il est resté fidèle à cette parole-fée et n'a cessé, dans sa technique, dans ses couleurs, en lui-même surtout, de changer et de cheminer. Il a connu bien des apprentissages, traversé bien des paysages, puis, quelques cols plus loin, il a trouvé son propre sentier, prêt à la solitude comme à la rencontre. Wang Yan Cheng sait, en chemin, se rendre disponible à l'Autre.

Partir, oui partir! Quand d'autres guignent la reconnaissance des estrades, dociles au tourniquet des honneurs. Point de récompense ici, si ce n'est la bénédiction du grand Tour, après ceux qui lui ont ouvert la voie. Wang Yan Cheng ne renie pas ses dettes, il poursuit le voyage tout à son entreprise de déconstruction. Ce qui subsistait hier encore du sujet, s'efface un peu plus. Place au vent, à la dissolution, à la fragmentation dans un entrelacs de formes coupantes, ondulantes. Le Premier homme peut s'approcher du seuil, il ne sera pas dépaysé. La boucle est bouclée, le témoin transmis.

Souvenons-nous du chemin parcouru. Longtemps, le peintre a travaillé dans son antre avec humilité, couche après couche. Débordant de vitalité, il n'a pas craint de multiplier les mélanges, empâtements et chevauchements. La réalité, sous le poids du labeur, s'est peu à peu dissoute à l'arrière-plan. Restent les voiles superposées comme autant de souvenirs. La quête se poursuit. Plein feux sur le mystère du frissonnement, du désenlacement où le vide perce toujours davantage dans ses grands triptyques. L'obscurité l'emporte même si la couleur fuse à certains endroits du tableau. Des aplats savants sinuent sur la cire déposée en fines pellicules. La victoire du vide résonne au loin. Nous sommes désormais dans le temps d'après la catastrophe. Aussi plus que jamais, convoque-t-il, au cœur de son œuvre, le

geste qui, seul, peut libérer, par la force d'un nouveau souffle, des fléaux et malédictions, sans oublier d'en appeler également au sablier qui dépose jour après jour son empreinte. Il renoue en cela avec l'esprit des peintures anciennes de son pays. D'un même mouvement, s'accomplissent la création et la révélation du pinceau qui s'élance à la surface du papier, comme de l'œil qui suit la cérémonieuse découverte du rouleau aux jours anniversaires.

Chaque tableau conserve sa propre horloge intérieure. Il se souvient des épreuves affrontées, des créatures et des chemins traversés. Mais l'harmonie qui jadis régnait en maître n'est plus le sens ultime de la quête, pas plus que la composition, longtemps objet de toutes les attentions du peintre, n'en est sa règle primordiale. Ce qui fut des années durant sa préoccupation quotidienne, rétablir un ordre à travers le choix des couleurs et des formes, n'est plus son devoir premier. Il y a de la rêverie dans ses toiles, une joie de déporter le regard, de sortir de soi-même, quitter son corps pour la pure couleur, peindre l'autre visage des nuages. Wang Yan Cheng a abordé au continent de l'irréel dont il a rapporté les couleurs, scintillant comme des gemmes dissoutes dans la paroi de toile. Couleurs d'outre-monde qui défient non seulement la représentation, mais font monter la nostalgie d'un monde-autre, plus plein, plus lumineux, plus exaltant. Nous mesurons comme le nôtre est terne et, nous, comme aveugles à la plus haute réalité.

A travers le mouvement, le geste ample et fougueux de l'artiste se dessine une nouvelle quête. Et, quand il pouvait craindre d'être accusé d'en faire trop, il prend le risque assumé aujourd'hui de ne point en faire assez. Une étape est franchie. Il s'émancipe des compagnons qu'il s'était choisi, Chu Teh-Chun, Zao Wou-Ki, Gerhard Richter ou encore Cy Twombly, l'un pour ses couleurs dansantes, l'autre pour ses combats tourmentés, le troisième pour ses dérèglements visuels, le dernier pour ses savants jeux de ligne. C'est qu'il a noué une nouvelle alliance avec les éléments déchaînés: la terre, les vents, les flots, le feu qui font un attelage étonnant. Surtout, il refuse de s'aveugler, regardant le présent en face quand tout, autour de nous, se défait face aux assauts répétés de la mondialisation ensorcelée.

Surgit des tréfonds de la terre une nouvelle catastrophe nourrie, une fois encore, des mains même de l'homme, avec son cortège de tourments, tremblements et épidémies qui éclaboussent, déchirent et fouettent la toile. Dans le désastre lui-même, il puise son butin de joyaux et d'épices arrachés à la destruction et livrés en témoignages, pareils à des trophées. La violence s'impose, nécessaire dans son élan purificateur, sacrificiel, sur l'autel de la vérité. Car tel et bien le véritable objet de la quête et celle-ci ne va pas sans risque, abandon, obligation de dépouillement et d'ascèse. Les voiles qui, hier, s'agitaient encore, au cœur de l'œuvre, montrant tout en cachant, se révèlent aujourd'hui plus tranchantes. Elles piquent le réel, libèrent les images pour ouvrir les portes de l'invisible. Plus libre, le peintre peut voyager plus loin. Pour atteindre à l'harmonie, il éprouvait sans cesse le besoin de rajouter une tache de couleur ici, une couche là, jusqu'à trouver, de tous les temps compressés, juxtaposés, le moment juste, apprivoisé par les jeux de la couleur, des formes et de la matière. Dans le tableau, une

terre promise se dessinait, gorgée de sucs, de fruits, d'espèces vivantes, pour la rendre, non seulement plus habitable mais aussi plus désirable.

La catastrophe est passée par là, l'avenir s'est éloigné, plus illisible, plus insaisissable et pour Wang Yan Cheng le combat n'est plus le même. Dire, nommer, juxtaposer, ne suffisent plus. La figuration a passé, elle est désormais sans figure. L'abstraction elle-même ne suffit plus, face à la multiplication des lieux et des nombres. Ses armes se sont émoussées. Tout ce qui fut acquis, certain, adoré, doit être remis en jeu. De nouvelles armes doivent être fourbies. L'heure est aux fragments, à l'explosion, à l'éruption, au souffle premier qu'il faut retrouver pour redonner la vie. Sur ce chemin, s'il ne se résout pas aux artifices, il ne dédaigne pas la complicité d'un clin d'œil, la dérision des coloriages, en de multiples taches réminiscentes d'un ordre ancien. S'envole le souvenir des tableaux sagement accrochés aux cimaises des Musées.

Gageons que, pour l'artiste, il ne s'agit là que d'un passage, mais d'un passage nécessaire dans la mue qu'il s'est imposé. Vérité bien cruelle, quand elle impose à celui qui veut l'approcher de s'avancer au plus près de la ligne de front, là où peinture et Histoire sont inséparables. Le geste même de peindre participe d'une aventure, devient Révolution.

Pourtant, le fil que l'on tire, comme spectateur, d'une exposition à l'autre, reste vivant, fidèle à la terre d'apprentissage du peintre, à l'éveil aux paysages du Shandong. Aux verts et aux bleus des origines s'ajoutent les ocres, les noirs, les bruns qui puisent aussi dans le creux des montagnes et l'échancrure des côtes de la mer de Chine orientale. Sur les parois de la toile, il recueille toujours avec la même humilité, les signes et les traces, toutes preuves du visible, mais cette fois, il n'écarte pas le chaos, le vertige des trombes et des vides. Alors, la toile tout entière animée d'un même geste, travaillée d'une même épreuve, révèle en même temps le vaste mouvement des puissances qui dévore la scène et les détails minuscules qui laissent poindre vésicules et granules, filaments et linéaments sous l'œil aiguisé du médecin ou du savant. Du bouillonnement cellulaire au tourbillon astral, l'œil navigue sans effort. L'infiniment grand rejoint ici l'infiniment petit, saisis ensemble par la main de l'artiste. Dans les petits formats, c'est le talent et la patience du miniaturiste qui s'expriment. Les tableaux sont pleins, composés, solides, contenus comme des médaillons où l'on chercherait à garder le souvenir, le témoignage d'un monde dont on sait que bientôt, il ne sera plus. Dans cette mémoire intime, peut-être, derrière les voiles, y a-t-il l'autre versant des paysages de l'enfance? Des paysages au seuil de l'inaccessible: des couchers de soleil noyés par les brumes, les pentes vives et vertes d'une terre habitée par l'esprit, hantée d'humanité, pétrie de siècles. Dans cette mémoire, il y a la Chine, il y a l'homme tout entier.

Sur la ligne des formes, on ne s'étonnera pas, puisque l'aventure nous mène bien au-delà de ce que notre regard peut capter, que l'abstraction également, dans un mouvement inversé, rejoigne le réel. La main de Wang Yan Cheng libère une nouvelle liberté de voir, à travers lentilles et prismes nouveaux.

Le désir reste vivant sur la grande scène du tableau. Il y a là encore, quelque chose qui échappe à la captation et nous tient dehors, sur le seuil d'une histoire qui, le peintre le sait, n'est pas finie, dans l'attente d'une autre révélation.

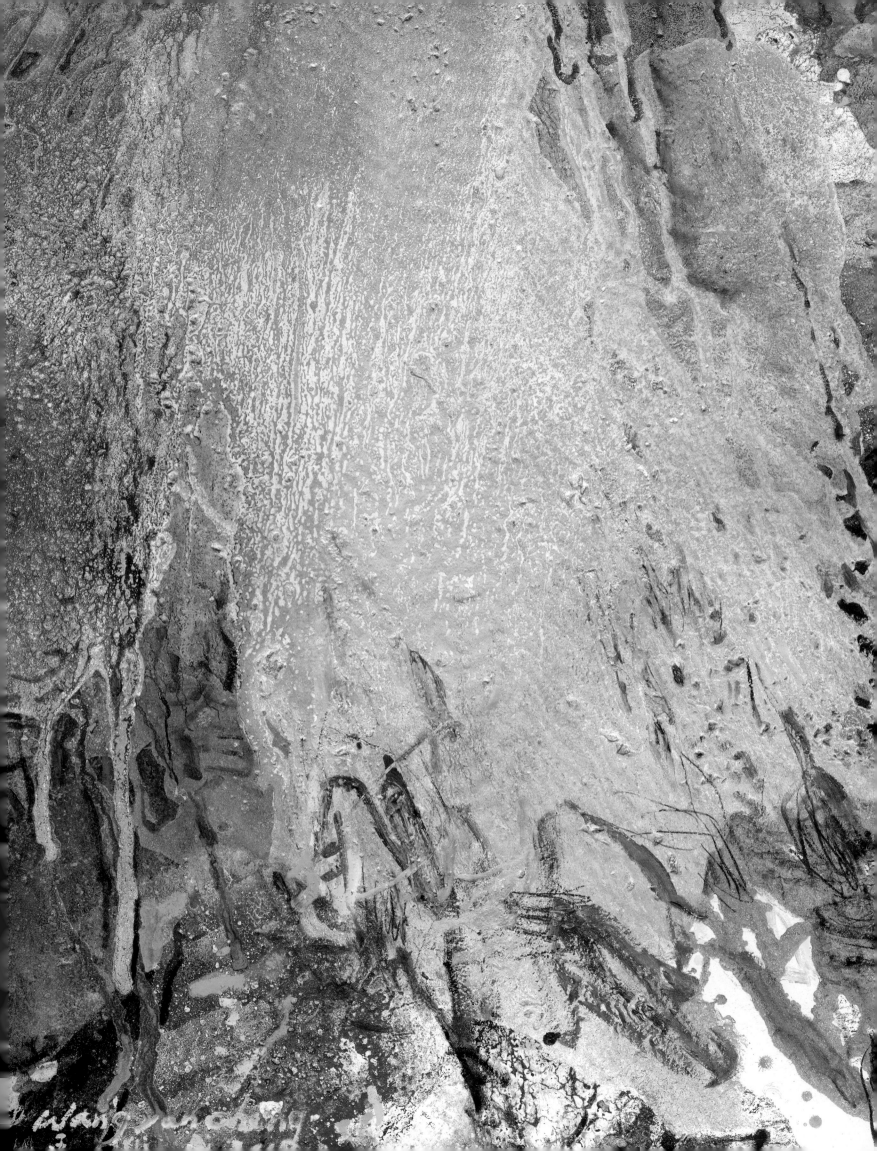

# 镜像中的 王衍成

## 德.维尔潘（法）作

迎着阳光在水坑间跳跃，在沙与卵石间游走，让心随着小纸船去游历....在我的朋友王衍成身上，有着童趣，有着一颗认幻想带向远方的自由心，既勇于挣脱羁绊，又不睥睨先祖之尊。时代层叠铭印，从中透出一道幽远的光芒。这里，画的肌理依然激情颤栗，那边，几抹淡淡的彩虹已挂在画幅的一角。

画家的忧虑关乎未来。他头顶探灯踽踽独行，搜寻天地间的迷宫，直至遥远的的边镇，看脚下边界模糊，岩石分崩，望天空乌云密布，他被神秘笼罩，却毫无惧色，只为探游而兴奋不已，日与夜在宁静的神游中安然交替，他标注些时段，自信于过往。明天，自会为他助力，因为他相信先行者，深知自己并不孤单，随他而行的，还有那些被遗忘在半途和曾经失去希望的人们。

他恢弘的画作，无限宽广，丰富充盈，吸引着人们，就象一本植物志，不断收集着各种符号、物种和绝迹的遗存。他信守回报，观众尽管安心，瓜熟蒂落之时，他自会现身。我们在画布的镜像中，隐约看到了一个男人的宿命和一股凝结了精神与物质的喷薄欲出的能量，还有那游走于明天暗地之间的自然神力，它们萌发有日，当来则来！王衍成比任何人都懂得召集这些遥远的能量，信手拈来，随笔而注于画中，钉入画框。这些强烈能量的迸发，表现于画中各种颜色的混合，犹如繁花轻撒，花边镂空，虚无缥缈，又仿佛返璞归真。就象经过火的洗礼，每幅画在见证了波涛汹涌的旅程后，终获自由。

画家的幸运从何而来？他闪烁其词，但内心镇定自若。人开始下定决心的时候往往宁愿沉默。王衍成是位谦逊的大师，面对时代的苛求，同时出于自身内在的渴望和对绘画的承诺，他可以毅然抄起朝圣者的拐杖，出发，前往一个新的国度—法兰西，去种植他自己的根脉；他也可以，在名满画界之后，再去躬身学艺，进而彻悟，绘画应该升华成画家与画布之间灵与肉的搏斗。今天，他就是在用整个躯体来绘画，奋力从画面中拽出生灵的颤栗，由此令情感破茧而出，如花怒放。

---

WANG YAN CHENG | *Untitled* [detail], 2019 | oil on canvas | 59 × 59 inches (150 × 150 cm)

他的谦逊，他的文静贤雅，引导他全身心地奉献于绘画。在一个自欺欺人并幻想天生正确的年代，对人对己，只能求得明哲保身，他也知道，要接受自我迷失，才能变成自我。灵魂需通过求索而得，而非在启程之初。他的名字，在汉语中意为变化、演进，他遵从了这个仙咒，不断地在技法上、色彩上，特别是对自己，求变，追索。他几度拜师学艺，穿过无数风景，走出几个山口，找到了自己的小径，处孤独而不悲，遇相聚而弗喜。在前进的道路上，王衍成懂得了如何让自己有益于客观世界。

出发，再出发，当别人在觊觎讲坛的承认，俯首听命于荣誉的旋转门的时候。若不是承蒙轮回的恩典和前人开出的路，征程中本没有酬劳。王衍成不否认他的欠债，旅程中他全力进行着解构的实践，从前尚存的执念，逐渐抹去，让位于风化、分解，各种错综复杂的规格形式，逐一分崩离析。第一个大胆尝试的人靠近了门槛，从此他便不会背井离乡…

回忆走过的路，我们的画家曾经长久屈身自己的岩穴，带着谦卑，默默作画。他内心充满着顽强的活力，一笔笔，一层层，不厌其烦地将油彩混合、揉稠、交叠，实景，在浓墨重彩的挤压之下，渐渐消解于背景，留下的，是层层柔纱，朦胧如无尽的回忆。寻觅并未中止，在王衍成的巨幅三联画中，虚空更多地显露，揭示着内心的震颤和解脱的秘密。但当颜色在某处发散，黑暗也会占了上风。恰如其分的均匀色调温润地铺撒在蜂蜡的画面，形成了细致的凝膜，远处，虚空吹响了胜利的号角。从此我们进入了"后灾难时代"。从此，在他作品深处，加倍地调动起宏大的气度，带着一股新鲜有力的气息，去冲破世间的灾祸与诅咒，当然，这壮举依然需要求助时间的沙漏，日复一日，为这波澜壮阔的场景刻上自己的印记。从中，他也找回了与中国古代绘画精神的血脉相联…

王衍成的每幅画都有着自己内在的时钟，它们记得所经历的艰难险阻、发明创造和漫漫长路。但是今天，曾经主宰和支配大师的"和谐"，已经不是探寻的终极意义；还有画家一度萦绕于心的"结构"，如今也不再是他绘画的首要尺度。曾经多年以来，他念念不忘的是在选择颜色和形式的过程中建立起一种秩序，现在这已经不重要了，重要的是画布上有梦想，有一种挪移目光、跳出自我的喜悦，那是一种脱离躯体、追求纯色、画出云彩的另一种面孔的喜悦。王衍成抵近了一个非现实的大陆，从那儿他带回了熠熠闪耀的色彩，象宝石散落于画板之上。那是来自彼岸的颜色，它既挑战了"表现"，又制造了对另一个世界的思恋，那个世界更充实，更明亮，更令人兴奋。我们在揣摩思量，因为我们的想象黯淡无光，就象盲人追寻着更高的真相。

艺术家激情豪迈的挥洒，勾画出一种新的探寻。当初他还惧怕被指责走的太远，而今天看来其实做得还远远不够。一个阶段就这样跨越过去了。如今他正在摆脱自己曾经选择的同道，他们是那样地特点鲜明：朱德群，色彩跳跃；赵无极，在焦虑中鏖战；里希特，狂放不羁，无常错乱；汤波利，线条游走，高妙无比。与他们渐行渐远，是因为他与狂野的自然之力订下了新的联盟：大地、狂风、巨浪、烈火，结成了神勇的战队。尤其，目睹当前周边的一切，正在全球化的魔潮中分崩离析，他不愿视而不见。

一个由人类亲手培育的灾难，伴随着痛苦、震荡、病疫，再一次从地底深处涌出，这景象撕扯、抽打着艺术家的画面。在灾害的废墟中，他发掘出堪比珍宝和香料的战利品，就象缴获的盔甲，佐证着战功。在他涤罪的激情中，在他祭献给真理的祭坛上，暴力必不可少。因为，这正是探寻的目的，而探寻本身，也少不了冒险、舍弃，时而还伴随着蜕皮、禁欲和苦行。曾几何时，蒙于作品中心的那层层薄纱还在轻摇，深

意半遮半掩，而今，它们变得锐利无比。它们刺破现实，为影像打开了一道道隐形的门。他更自由了，可以走的更远。为了达到和谐，他不断感受到一种需求，就是要不时地在这儿加点色，在那儿涂层彩，直到在纵横交错的时空内，在形式和材料的博弈中，找到那正确的一刻，这时的画面，已被绘成一片乐土，它包含汁液，硕果累累，生机勃勃，既引人栖居，更令人神往。

灾难既至，未来渐渐远离，它变得更加难以捉摸，无可企及，而对于王衍成来说，战斗已截然不同。诉说、命名、叠彩施墨，已然不够，形象展现已成过去，从此已无象可现。抽象本身，面对世间万物之纷繁，也已力不从心。他手中的武器变钝了。从前获得的一切，曾经实实在在，令人爱不释手，现在都要推倒重来。新的武器要擦亮，时代属于碎片的爆炸、迸发，属于那一口能唤回生命的阳气....记忆中的那些静静挂在博物馆墙壁上的画幅，正在飘然而去。

我们不妨打赌，对于画家来说，这也许又是一次短暂过渡，但对于其势在必行的蜕变，委实必要。真相是残酷的，当有人想靠近她的时候，她便强迫他走向探索的最前沿，在那里绘画与历史混为一体，即使挥笔作画的动作都趋向冒险，几近革命。

然而作为观者，从一个展览到另一个展览，我们追随画家的那根主线依然鲜活，它依然忠实于画家学艺之初的土地，陶醉于其山东故乡的美景。就连在初始的蓝绿色调中添加的赭石、鳖黑和深棕，也仿佛是从东海的弧形海湾和岸上沉郁的山坳中汲取而来。在整幅画布上，他以一贯的谦卑，集拢了各种符号、印记和一切可见之据，然而这一次，他没有躲避混沌、虚空以及如龙卷风般的晕眩。于是，一气呵成、气贯长虹的画面，便同时展现出两重景象，一面是各种力量卷起轩然大波，吞噬舞台；另一面则是纤丝粟粒针毫毕现，犹如疹粒水泡暴露在医生如炬的目光之下。从细胞分裂的沸腾翻滚，到天体星辰的涡流璇涌，观者的目光尽可随意流连，自由逍遥。

须弥纳芥子，天地万物，大师玩于股掌之间。在小小的画幅中，凝聚的是画家的才情与耐心，它们如此饱满，意味深长，坚实稳固，就象纪念浮雕，用来保留某个世界的回忆和佐证，明知这个世界将不复存在。或许，在这种内心的隐秘记忆中，在层层轻纱之后，还有画家童年别样的景色？一些只可远观而无法近临的风景：几缕夕阳溺于暮霭，鲜活、翠绿的大地和山坡，隐匿着神灵，充满着人性，世纪交替，绵延不绝。在这个记忆里，有中国，有画家完整的灵性慧根。

在整体形态上，由于新的探索已经把我们引向目光所及之外，因此，我们也并不惊奇，抽象以一种相反的运动，同样可以回归本真。王衍成通过新型棱镜的透视，亲手释放了一种新的视觉自由。

画作长袖善舞，欲念依然栩栩如生。有些东西我们无法琢磨，只好置身于外，只有画家知道，故事还没结束，新的发现指日可待。

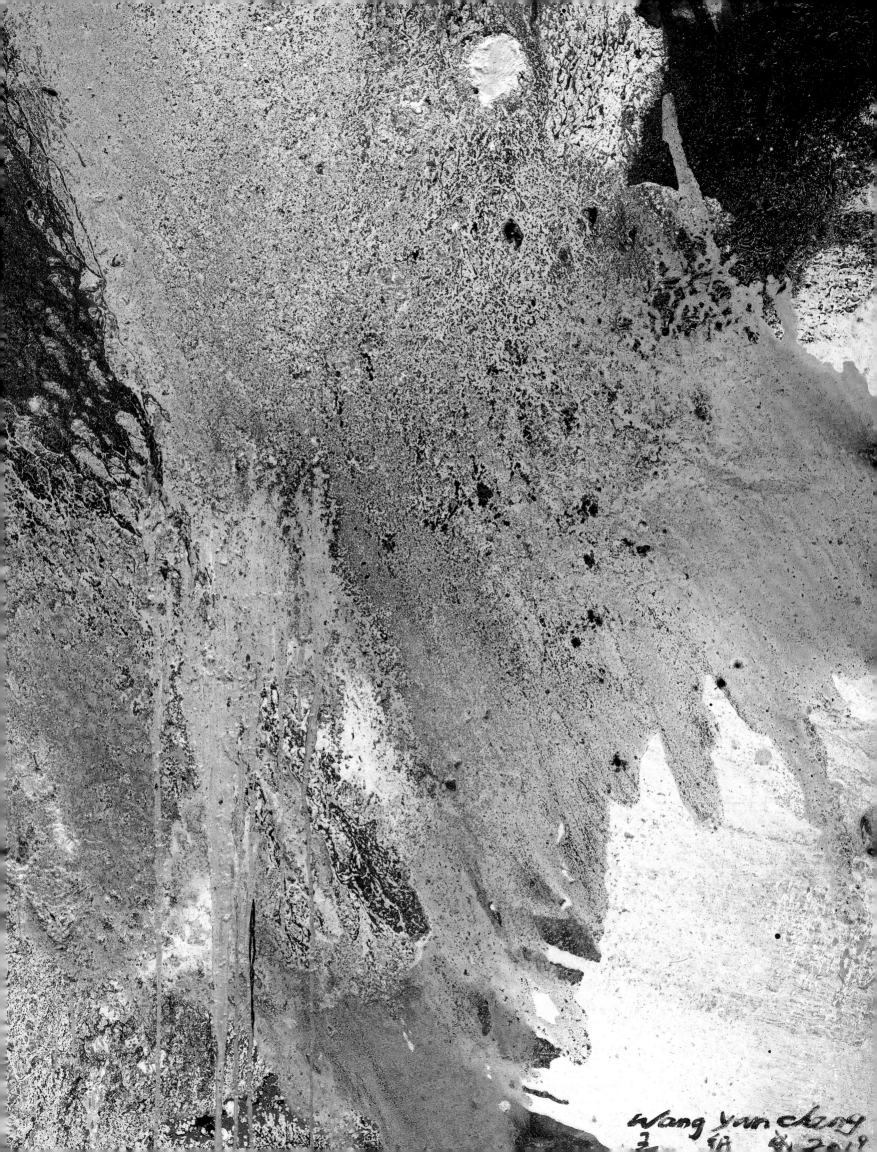

Wang yun cheng

# INFINITE PAINTING

## Gabriele Simongini

Painting becomes nature; it does not imitate it in its superficial appearances but becomes an integral part of it through its formative process of germination, birth, and growth. And through this painting the artist who gives it life, Wang Yan Cheng, states with poetic force that human beings must return with respect and measure to feel part of the natural world, leaving aside any mad intent of aggression and domination of the environment. From his work emerges a passionate short circuit and then a deep osmosis between energy and desire, between colossal sublime forces of nature and the dynamic and fluctuating ones of the self. In addition, Wang Yan Cheng, Chinese by birth and French by adoption, can now look back, with fresh eyes, at the ancient and glorious tradition of his country of origin, after he has lived and worked in Paris, proving to be a Radicant of painting. Radicant is the term coined by Nicolas Bourriaud in 2009 using a botanical metaphor. Bourriaud writes, "It is the artist who develops his roots as his growth progresses whilst wandering the world. Being rooted, staging, setting off one's own roots in contexts and heterogeneous formats, denies him the possibility of completely defining his identity. Translating ideas, transcoding images, transplanting behaviors, exchanging rather than imposing." The term "rooting" (derived from fusing the words root and wandering) implying the opposite of "radical" which carries with it the idea of permanent root. In reality, Wang Yan Cheng is a Radicant *sui generis*, certainly not verifiable to the list of artists of which Bourriaud speaks, because he prefers the specificity and permanence of the pictorial medium with a choice of univocal field. And in this sense, opposed to the obsession of instability, linguistic wandering, the ethics of precariousness and the ephemeral so dear to the dominant art system of today. If we start from the principle that the most decisive artistic inventions have the ability to modify the sensitivity of the human race by opening up new paths to the way we experience the universe through a predominantly emotional channel, then we understand that Wang Yan Cheng's research stems from new questions in the

WANG YAN CHENG | *Untitled* [detail], 2019 | oil on canvas | 59 × 59 inches (150 × 150 cm)

present time directed at the heart of being. He knows well that in our super-technological and immaterial age the survival of painting is an integral part of the preservation of some fundamental qualities of the human species. First of all, one that links the hand to intuition and thought in a creative unicom and each time different. As the brilliant architect and designer Gio Ponti used to say, "The hand, this exceptional medium, is part of thought because it not only interprets it but guides it at the same time, certain of its mysterious inventiveness." In the gesture of the current painter the echoes and the mnemic waves of a long habit of human beings are revived with this technique, which can now be considered an integral part of their DNA. From Wang Yan Cheng's painting emerges a question that today cannot be renounced; what is the emotional and existential truth that takes shape in the form?

For our artist, it is precisely painting, freed from any artificial presence that offers a contribution aimed at safeguarding the human authenticity of being in the world. For Wang Yan Cheng, painting is a biological liquid and his works, real natural phenomena similar to sunrises, sunsets, waterfalls or the impetuous eruption of a water source, continue to take shape before our eyes. Inexorably and inevitably, mutable and always mutant, as if they were animated by secret, mysterious, metamorphic forces. Forces which exert a constant, explosive seismic action on the surface, transformed into the energy field. The images seem to be created by color, as if an autonomous organism with its own will. Observing the works of Wang Yan Cheng, it is natural to share what was written by Werner Karl Heisenberg, Nobel Prize winner in Physics as well as one of the founders of quantum mechanics, "The same forces that determine the visible order of the world, existence and properties of the elements, the formation of crystals, the birth of life, may even be at work in the creative process of the human mind."

His paintings are also the skin of the world, with technical wisdom that moves sensibly between transparency, sudden and brilliant luminescence, opaque crevices and wrinkled overlaps, between welcoming deposits of colors and sudden cancellations. The artist tends toward being and emptiness by accepting the natural and spiritual becoming. He transforms painting into the fifth element that, in itself, revives and renews the energies arising from water, air, earth, and fire. This is clearly evident from time to time, in amniotic fluidity or in atmospheric expansions as well as in telluric concretions or in the flaming explosions of his works. Potentially, Wang Yan Cheng could paint immense canvases, exterminated like the sky or the sea, and this aspiration can be seen precisely in his most recent works. The sense of infinity and of the unlimited, interior, and cosmic at the same time, becomes one with his painting and from it emanates to us with extremely engaging results. It invites us to come out of the purely pragmatic dimension in which we are accustomed, to find those territories of the spirit and of the "sublime" we have forgotten. Precisely for this reason the inner exploration sought by Wang Yan Cheng is boundless. The psychophysical totality of gesture, borne of long meditation and concentration, enters into harmony with ever-larger surfaces, with colors that seem to gush from the inside of the canvas rather than from the outside. Then, to penetrate like a gentle wave or an

enfolding cloud in the depths more mysterious than the soul of the beholder. It is a process of emanation made of authenticity and purity, leading from the sensitive domain of daily existence to the whole of a fruitful, welcoming, germinal, aurora-like void in which the secret forces of life are protagonists. And of course Wang Yan Cheng could well share his reflection of affinity by Vasco Bendini, a secluded and sensitive protagonist of Italian informal painting, "I felt the need to look around me, I began to think about the universe, something above us, unspeakable." The world is an unimaginable thing of which we know nothing. One no longer has time for solitude because it is impossible for all to be deserted. And so here, in all the last paintings, I reinvent nature, the universe which I imagine on that day in which I realize the painting. And every time I imagine it differently, it has no limit. In this I realize that my psyche process materializes, that my psyche lives in the matter, indeed with the matter. Thinking, feeling is doing. Thus the painting of Wang Yan Cheng becomes a threshold between nothingness and infinity and color stands as a direct experience, as a presence and revelation at the same time. It is capable of immersing itself in the impalpable and the invisible. Also, going back to an appreciable concreteness, material with a haptic perception. A wonderful synthesis is thus achieved between visual and tactile spatial intuition, between illusory depth and a plastic surface favoring a wider involvement of our senses and our entire organism. Like a classic symphony, exciting waves of color overlap and then overlap again, reinforcing each other, occasionally merging into new and unpredictable covenants. Or almost jealously preserving their purity, giving the impression of passing from the aeriform state to the liquid or plasmatic one until the most concrete solidification, in a cosmogony, seeming never to end, in the tight alternation of great light trails and nocturnal thickening. Those waves of color are moved by a breath of life, by an airy breath that appears to us as a sort of original principle that has fallen into spring images. Images that perhaps arise from the more or less conscious ambition of "erasing everything from the blackboard from one day to the next, being new to every new dawn, in a new perpetual virginity of emotion [...] This dawn is the first dawn of the world," as noted by the great Portuguese writer Fernando Pessoa. They are spaces of origin (from the Latin *orior*), with the dual desire to be born and to rise, as we see in the works of Wang Yan Cheng. It is breathing with the spirit, to feel, once and for all, "What seas echo in us, in the night of existing, on the beaches we feel in the flood of emotion!" Each of us collapsed "in the blue of its inner heavens, in the clinking of its flowing rivers, in the soul," to once again paraphrase the incomparable Pessoa. The moment of apparition and that of disappearance meet in the painting of Wang Yan Cheng and seem to coincide almost miraculously, keeping intact a secret vitality on the threshold placed between the eye and the soul, the one where images destined to change our life are born.

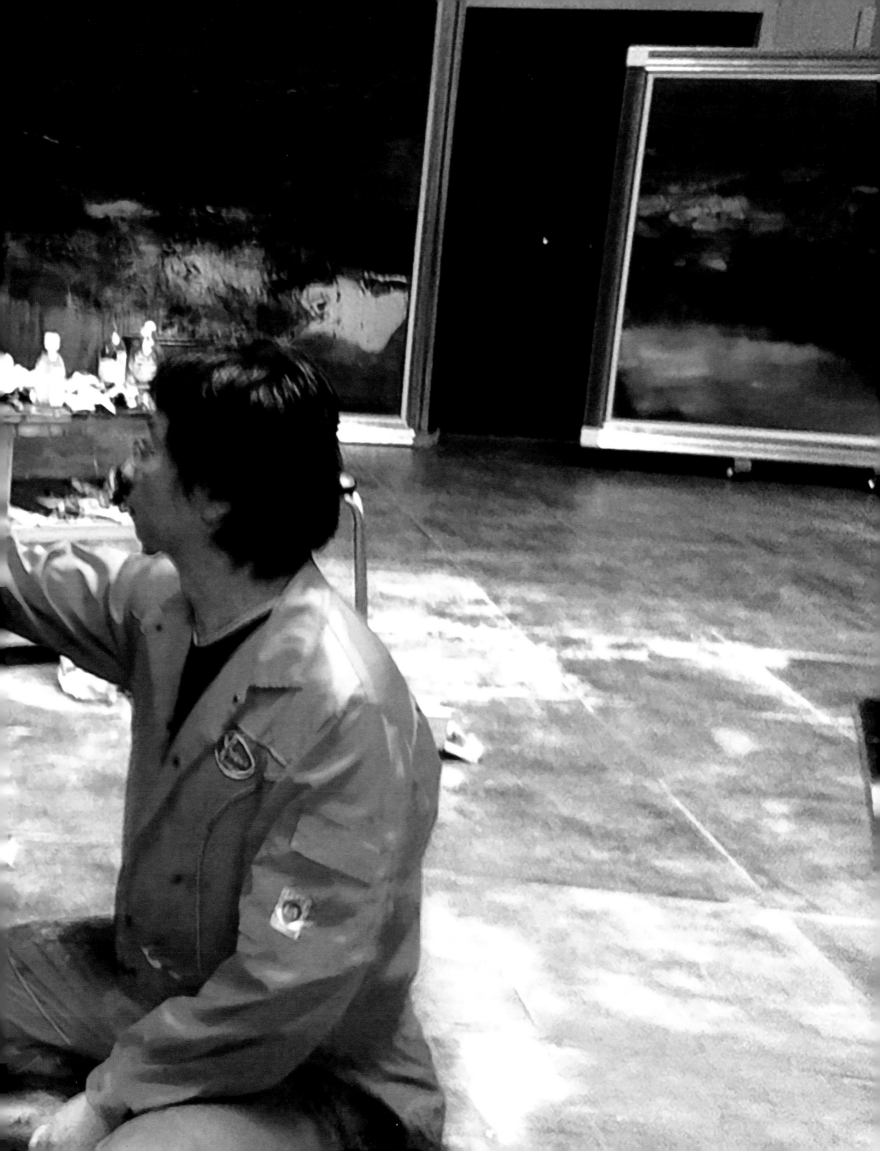

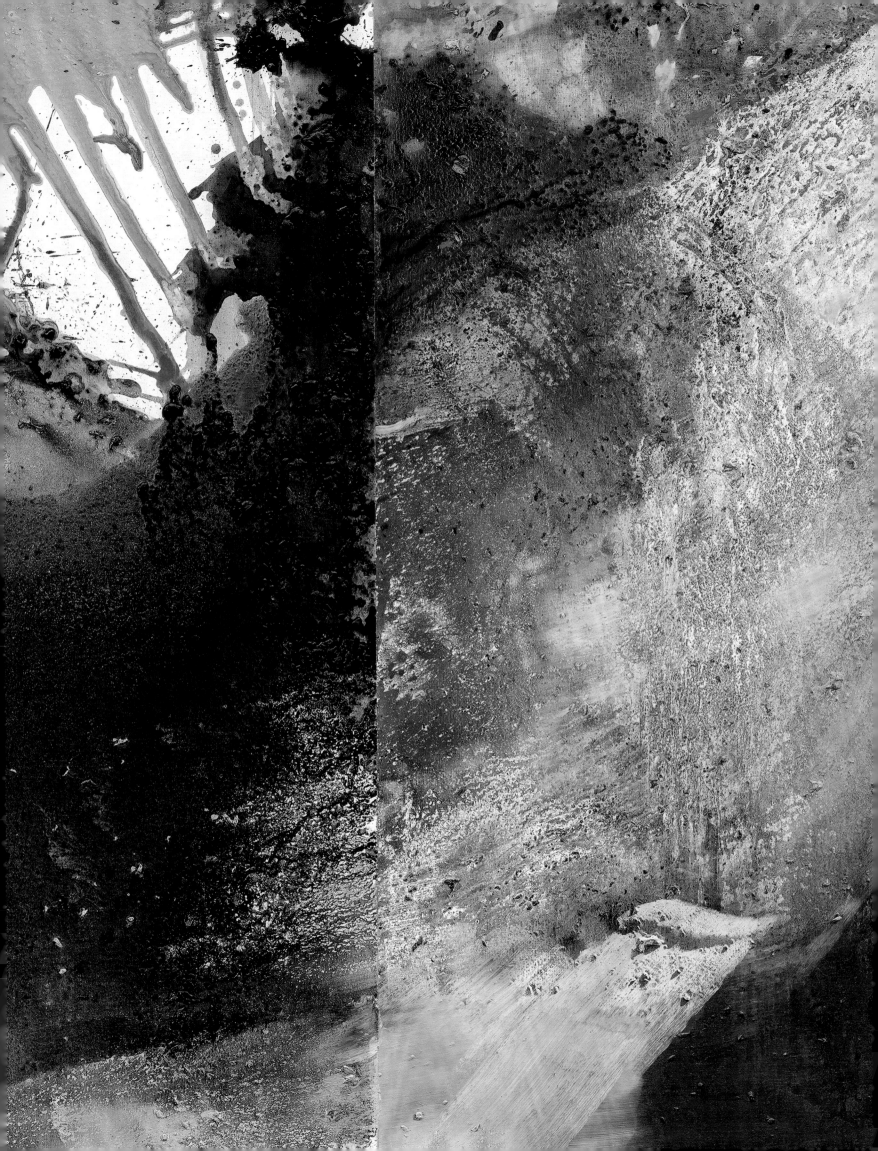

# WORKS
# IN EXHIBITION
# 展览作品

*Wang yan cheng*
*2018*

WANG YAN CHENG   |   *Untitled*, 2019   |   oil on canvas   |   78 3/4 × 78 3/4 inches (200 × 200 cm)

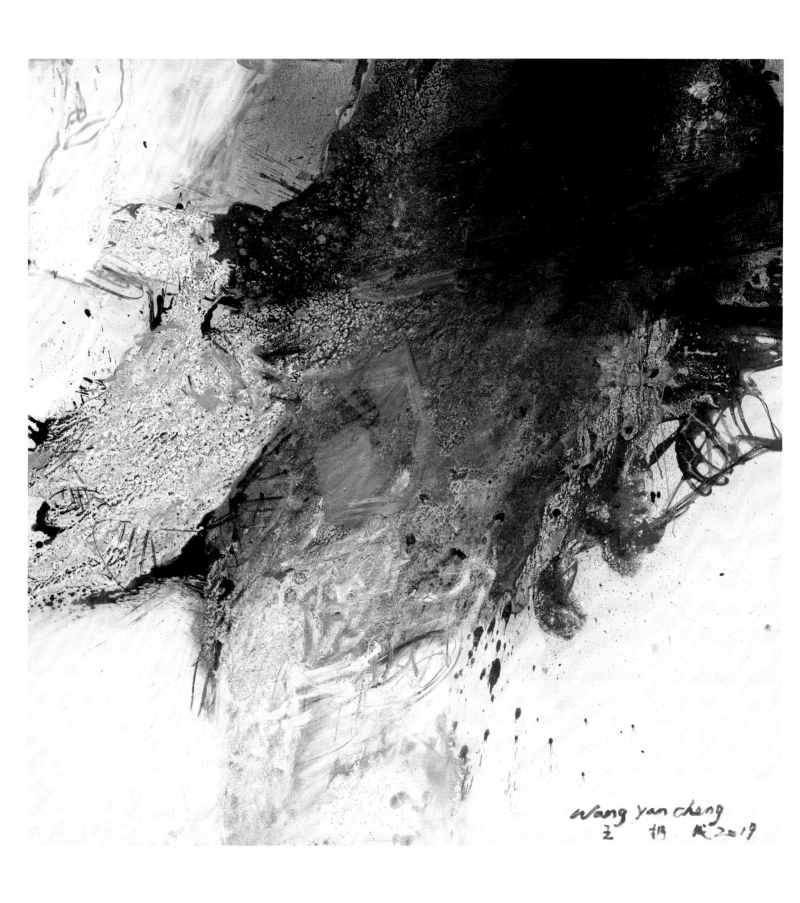

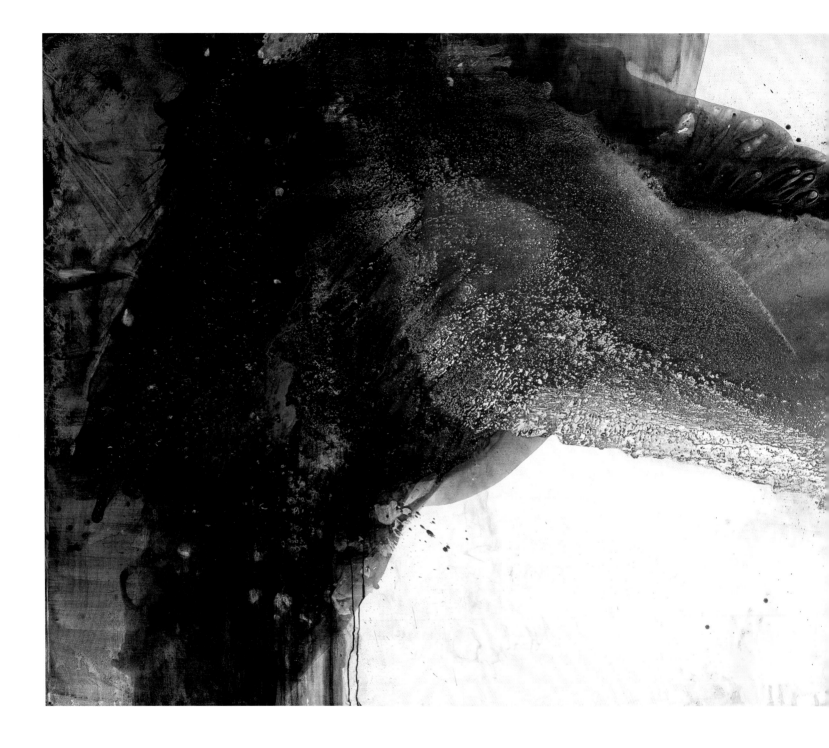

WANG YAN CHENG | *Untitled (Triptych)*, 2019
oil on canvas in three panels | 82⅝ × 307 inches (210 × 780 cm), each panel 82⅝ × 102 inches (210 × 260 cm)

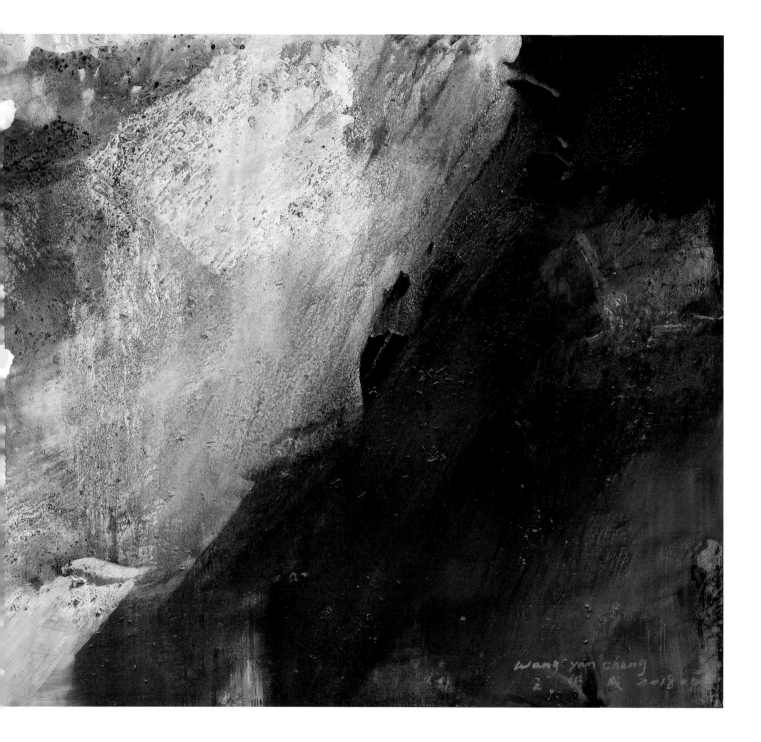

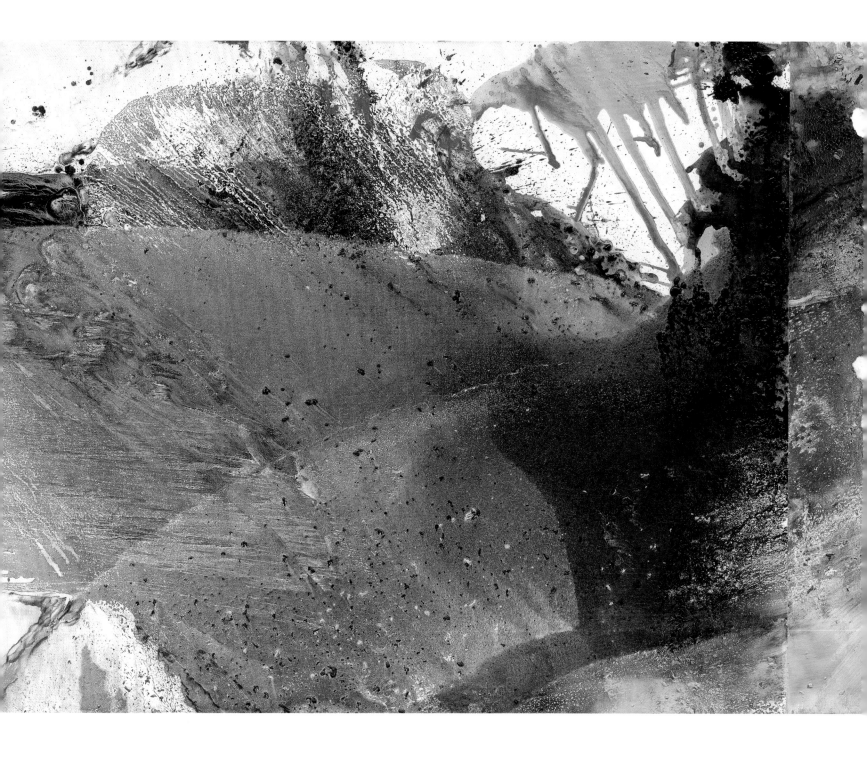

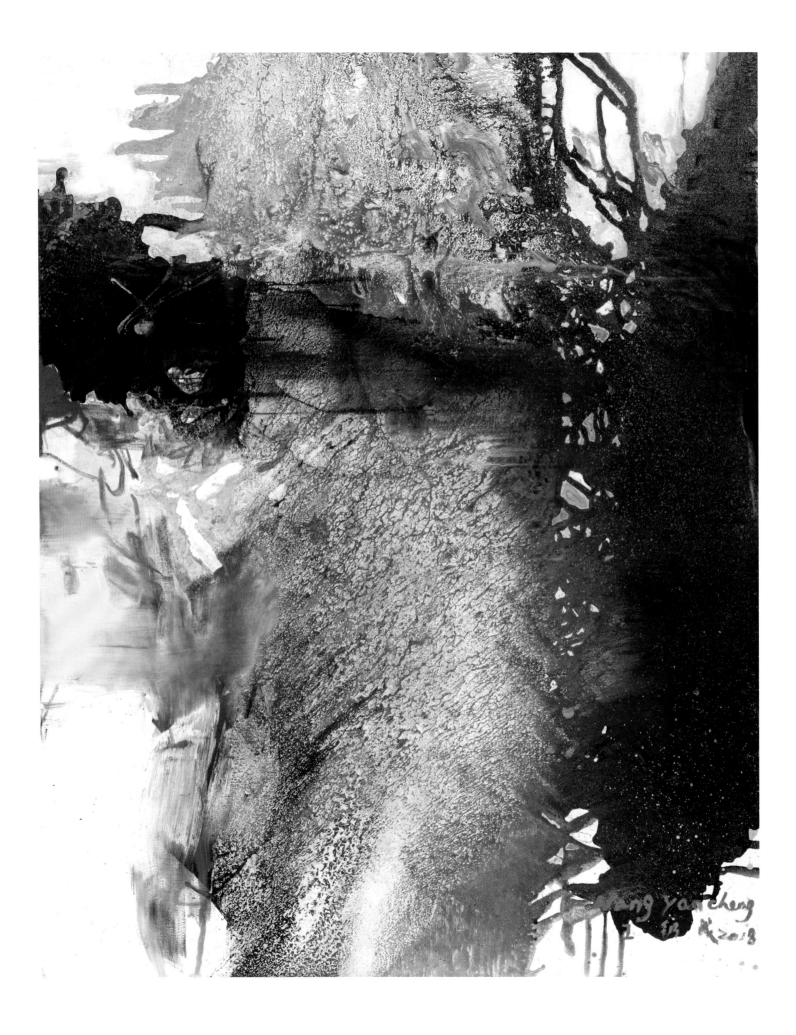

WANG YAN CHENG | *Untitled*, 2019 | oil on canvas | 102 × 82 5/8 inches (260 × 210 cm)

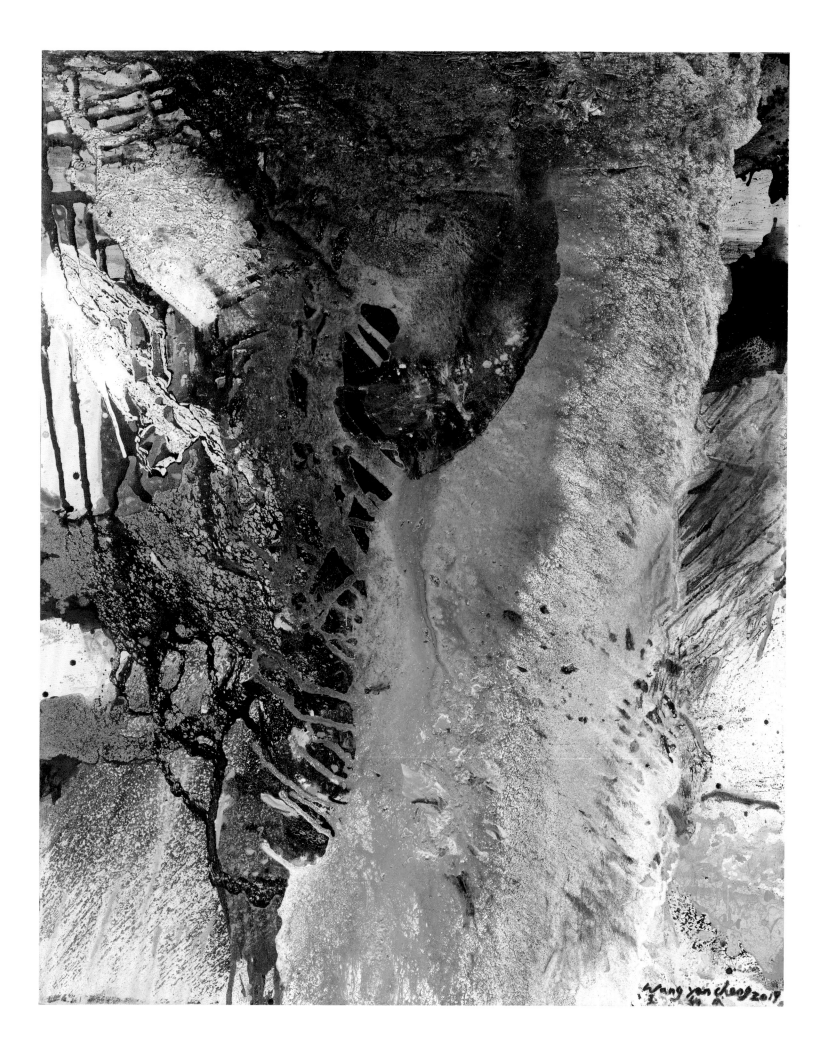

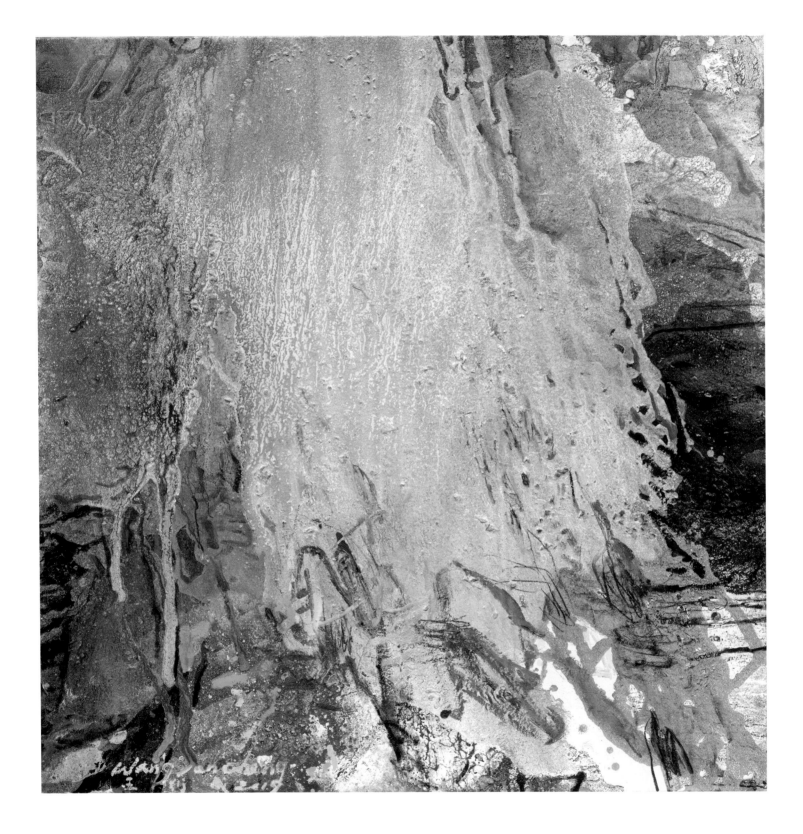

WANG YAN CHENG  |  *Untitled*, 2019  |  oil on canvas  |  59 × 59 inches (150 × 150 cm)

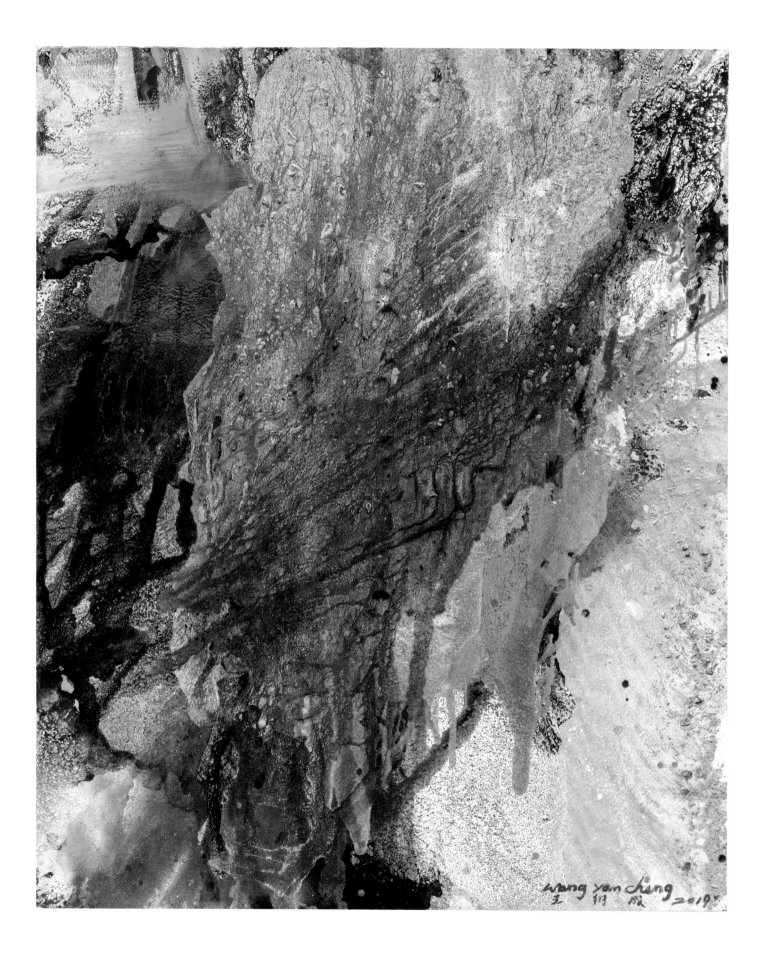

WANG YAN CHENG | *Untitled,* 2019 | oil on canvas | 71 × 59 inches (180 × 150 cm)

WANG YAN CHENG | *Untitled,* 2019 | oil on canvas | 36 ¹/₄ × 28 ³/₄ inches (92 × 73 cm)

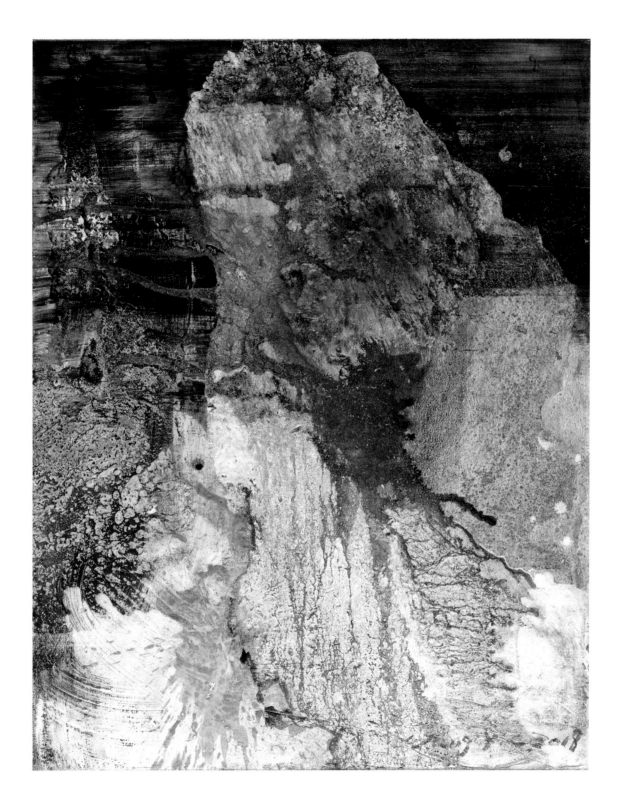

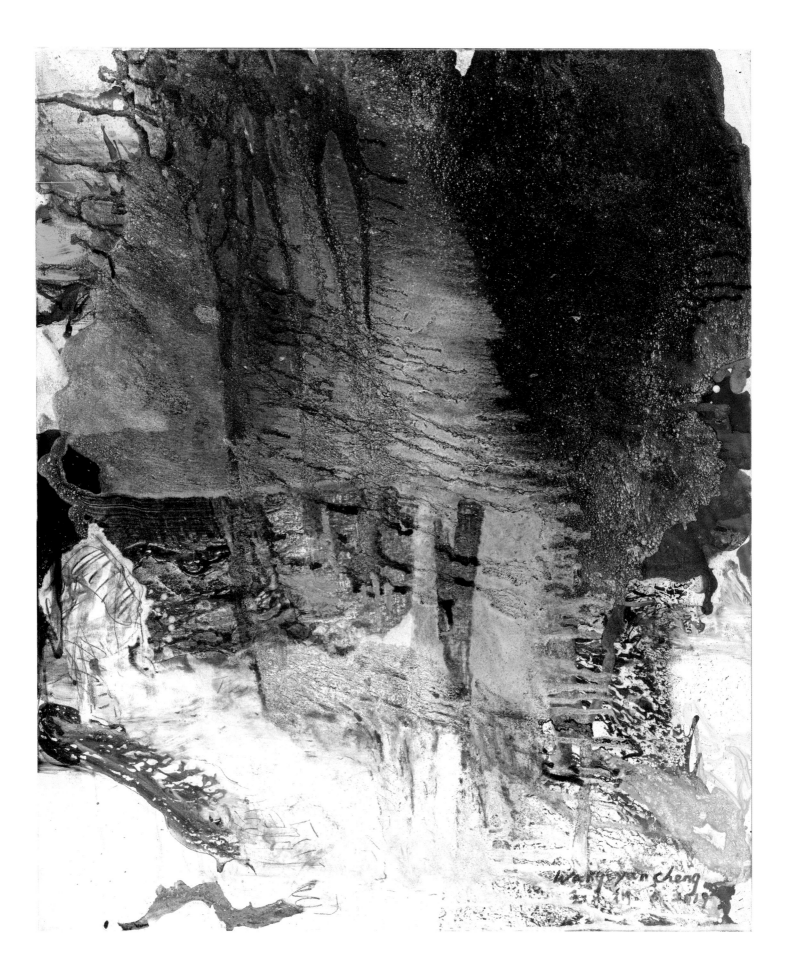

WANG YAN CHENG   |   *Untitled,* 2019   |   oil on canvas   |   74$^{3}/_{4}$ × 63 inches (190 × 160 cm)

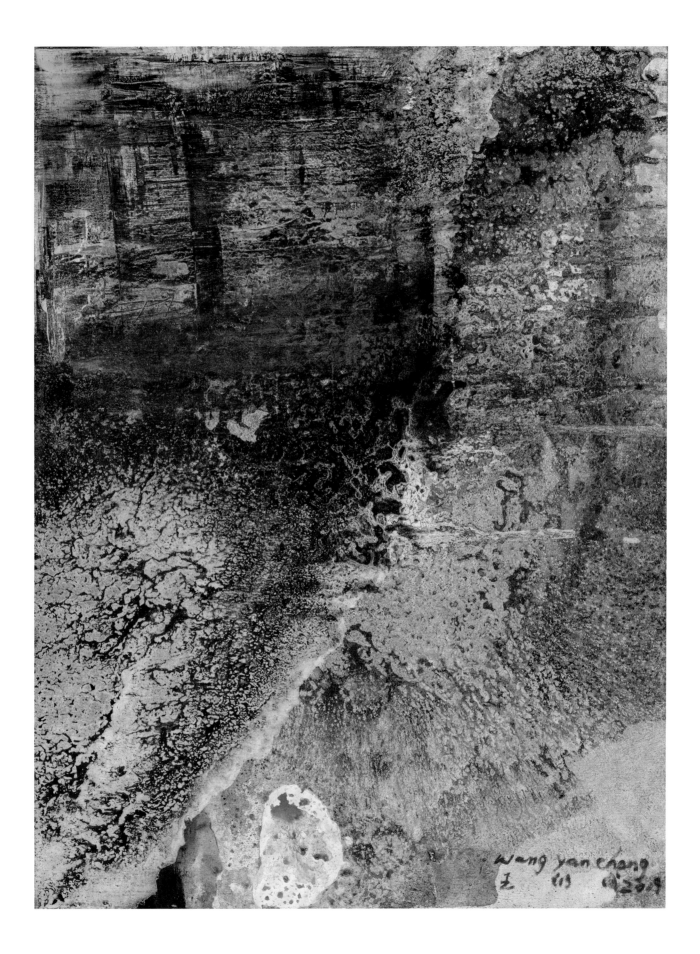

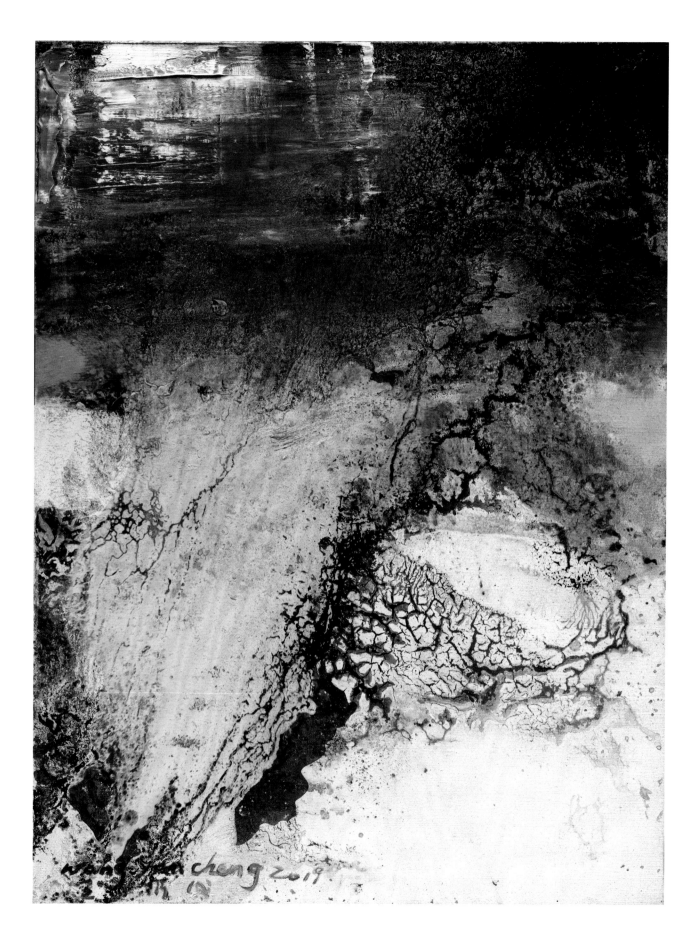

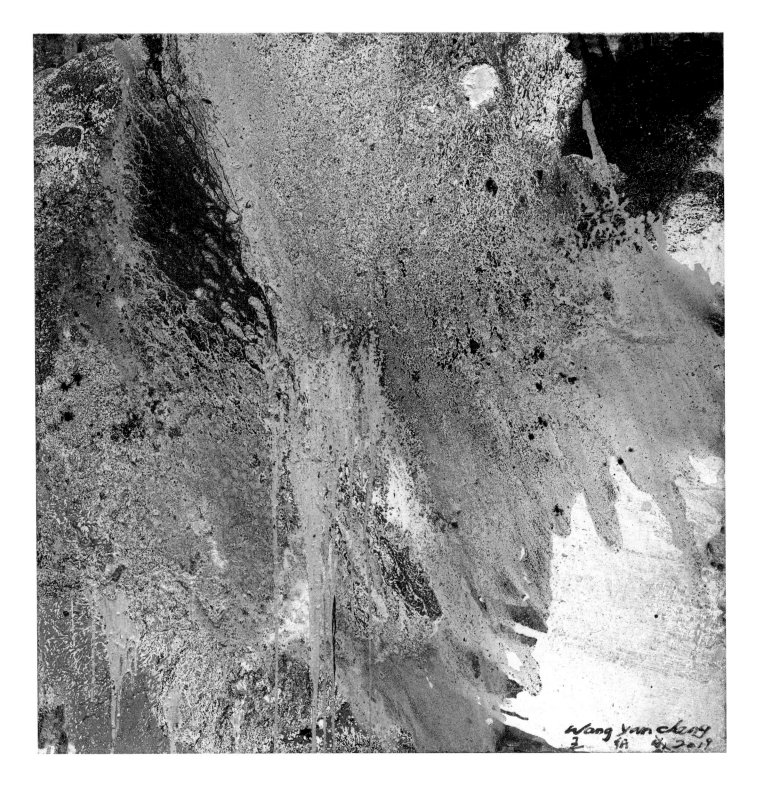

WANG YAN CHENG | *Untitled,* 2019 | oil on canvas | 59 × 59 inches (150 × 150 cm)

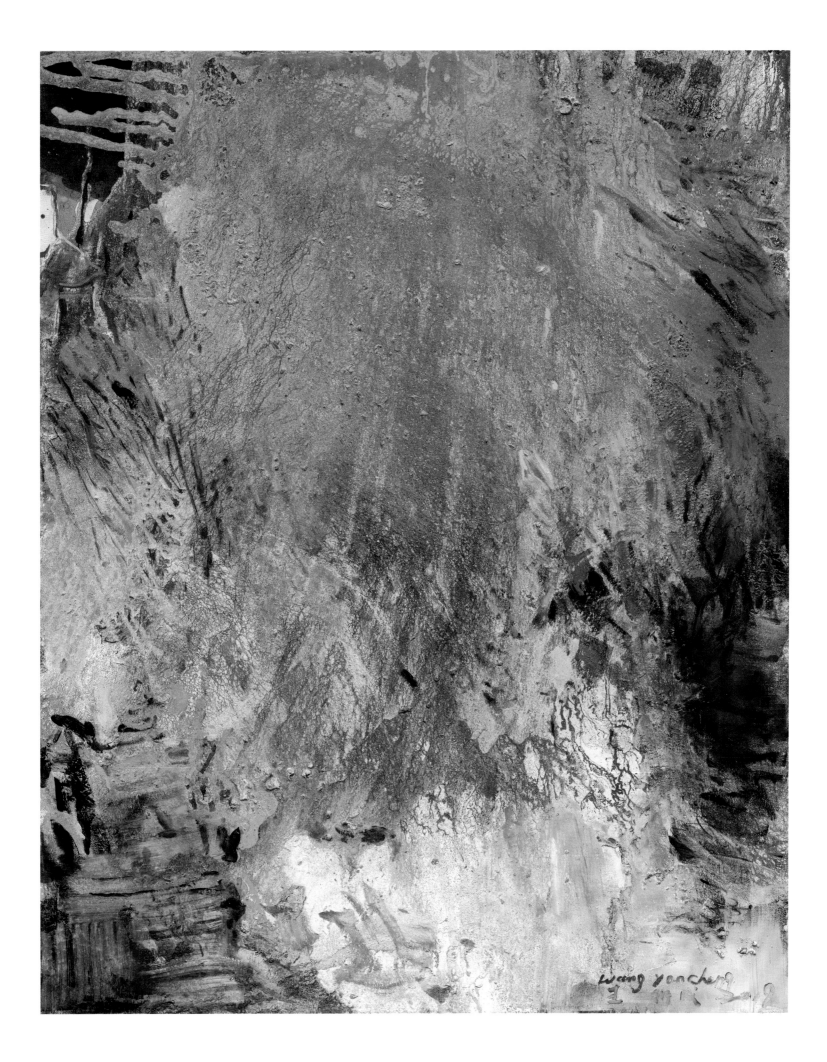

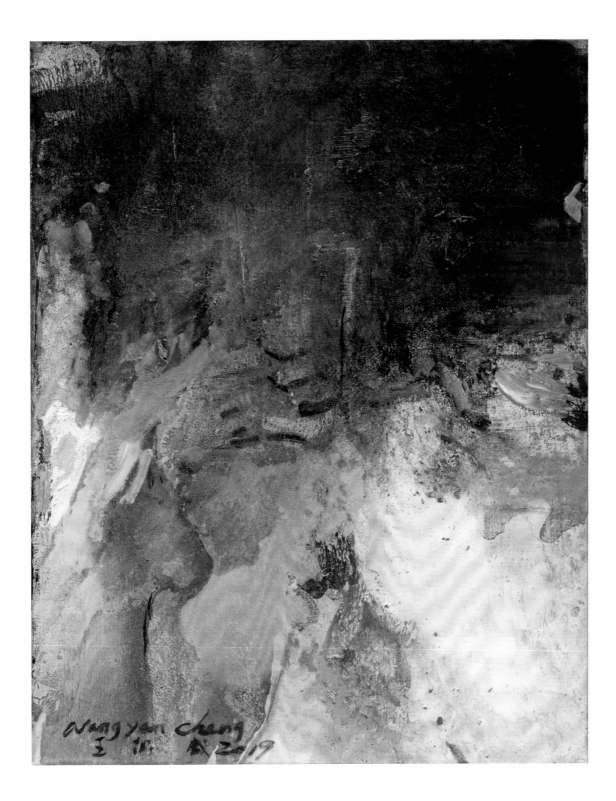

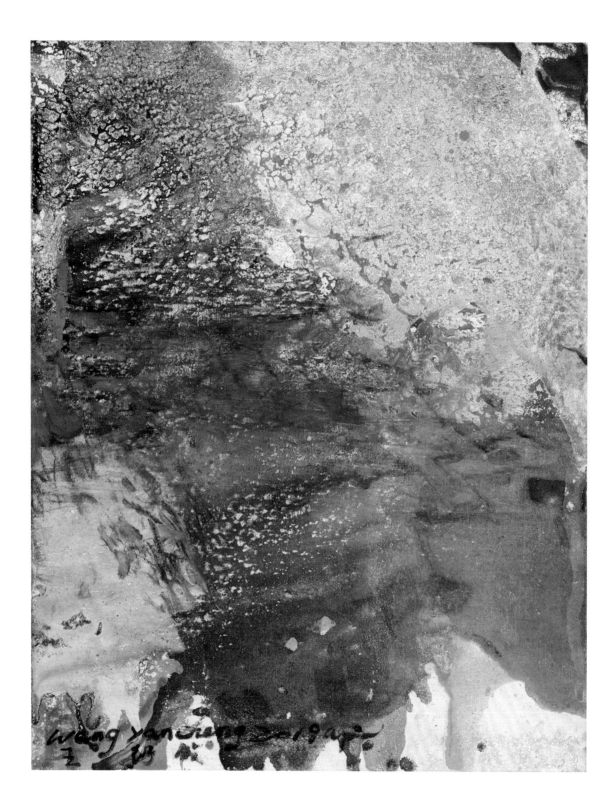

WANG YAN CHENG  |  *Untitled*, 2019  |  oil on canvas  |  36 $\frac{1}{4}$ × 28 $\frac{3}{4}$ inches (92 × 73 cm)

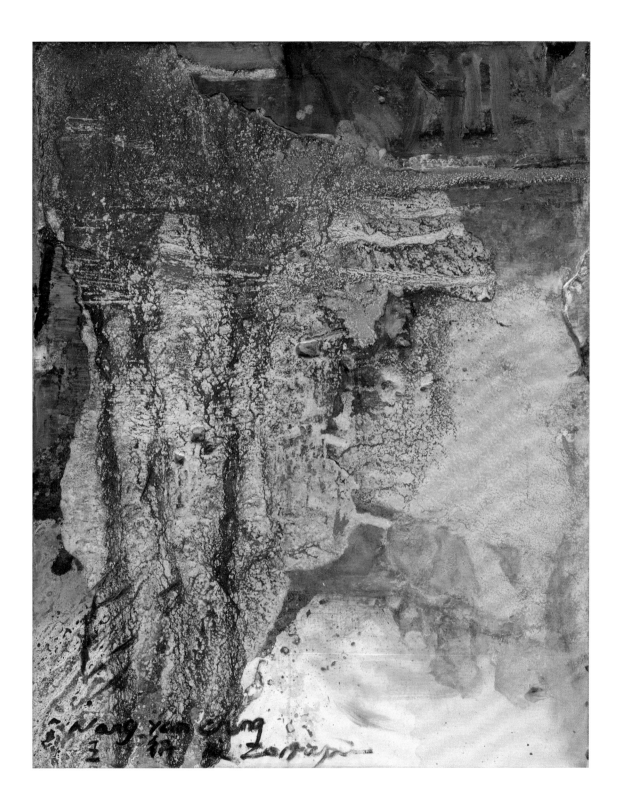

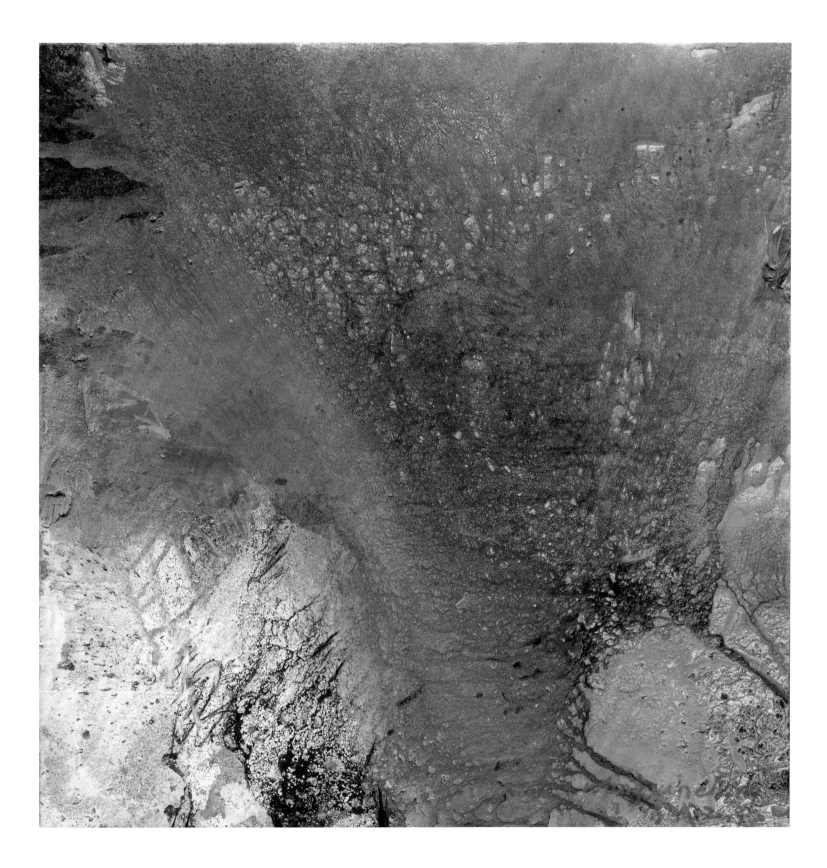

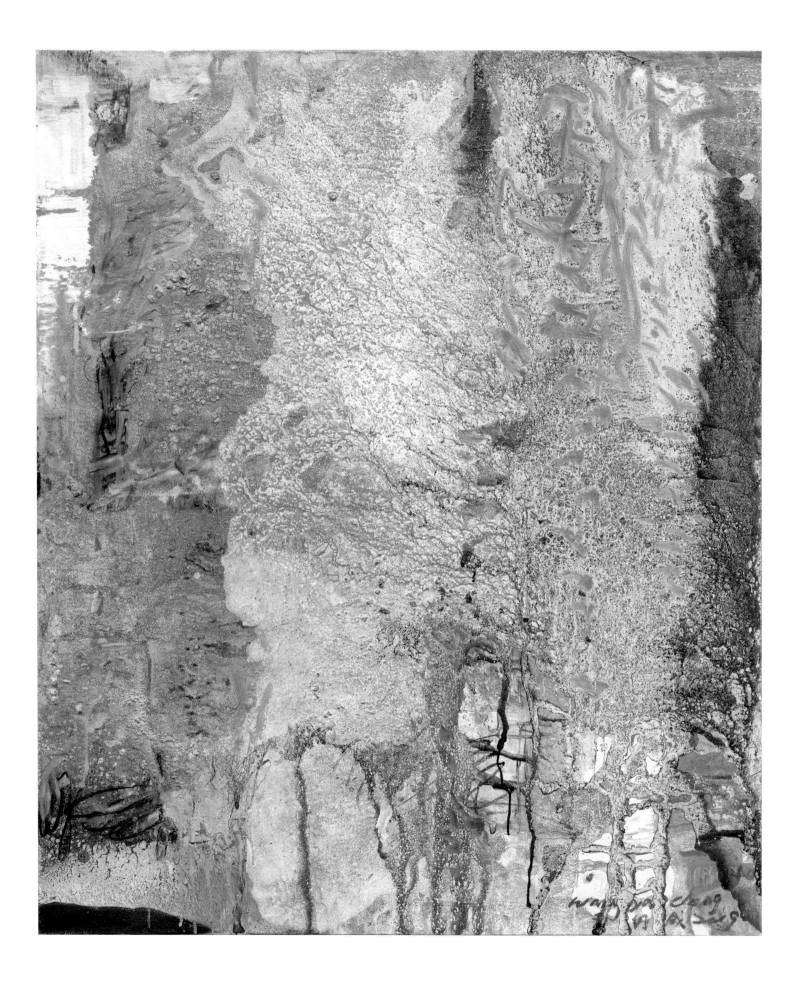

WANG YAN CHENG | *Untitled*, 2019 | oil on canvas | 71 × 59 inches (180 × 150 cm)

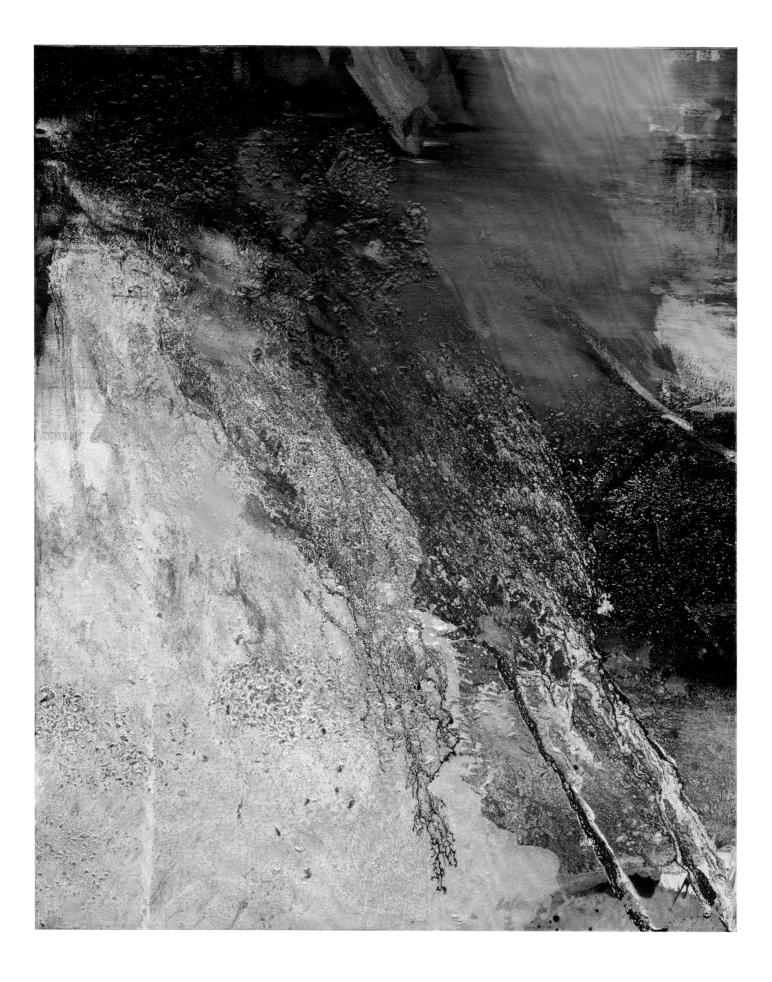

WANG YAN CHENG   |   *Untitled*, 2019   |   oil on canvas   |   71 × 59 inches ( 180 × 150 cm )

WANG YAN CHENG  |  *Untitled*, 2019  |  oil on canvas  |  45 $^{5}/_{8}$ × 35 inches (116 × 89 cm)

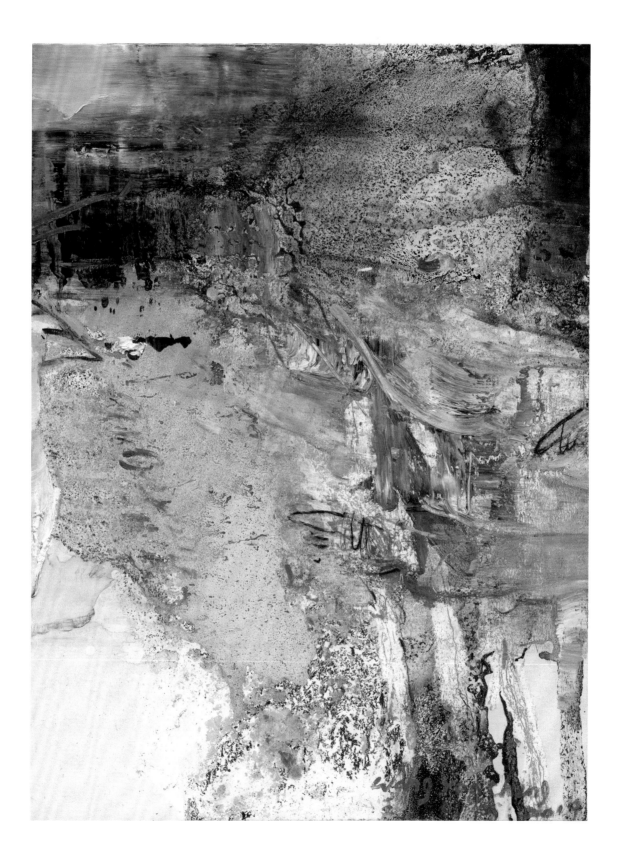

WANG YAN CHENG ｜ *Untitled*, 2019 ｜ oil on canvas ｜ 71 × 59 inches (180 × 150 cm)

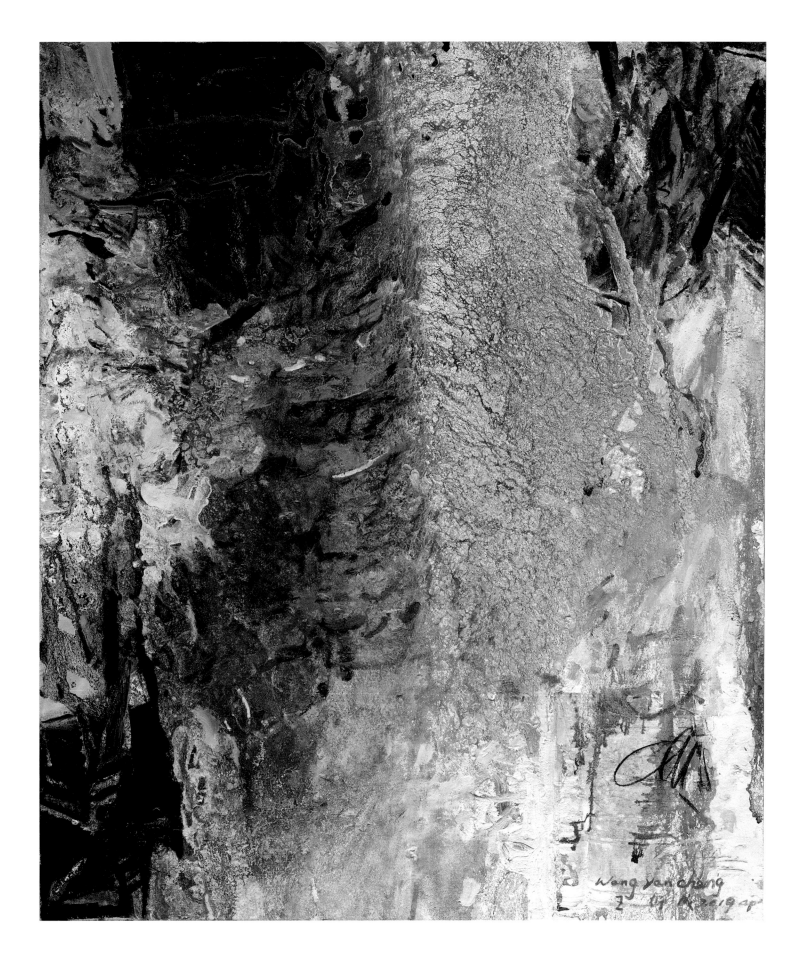

# BIOGRAPHY AND CHRONOLOGY
## 简历

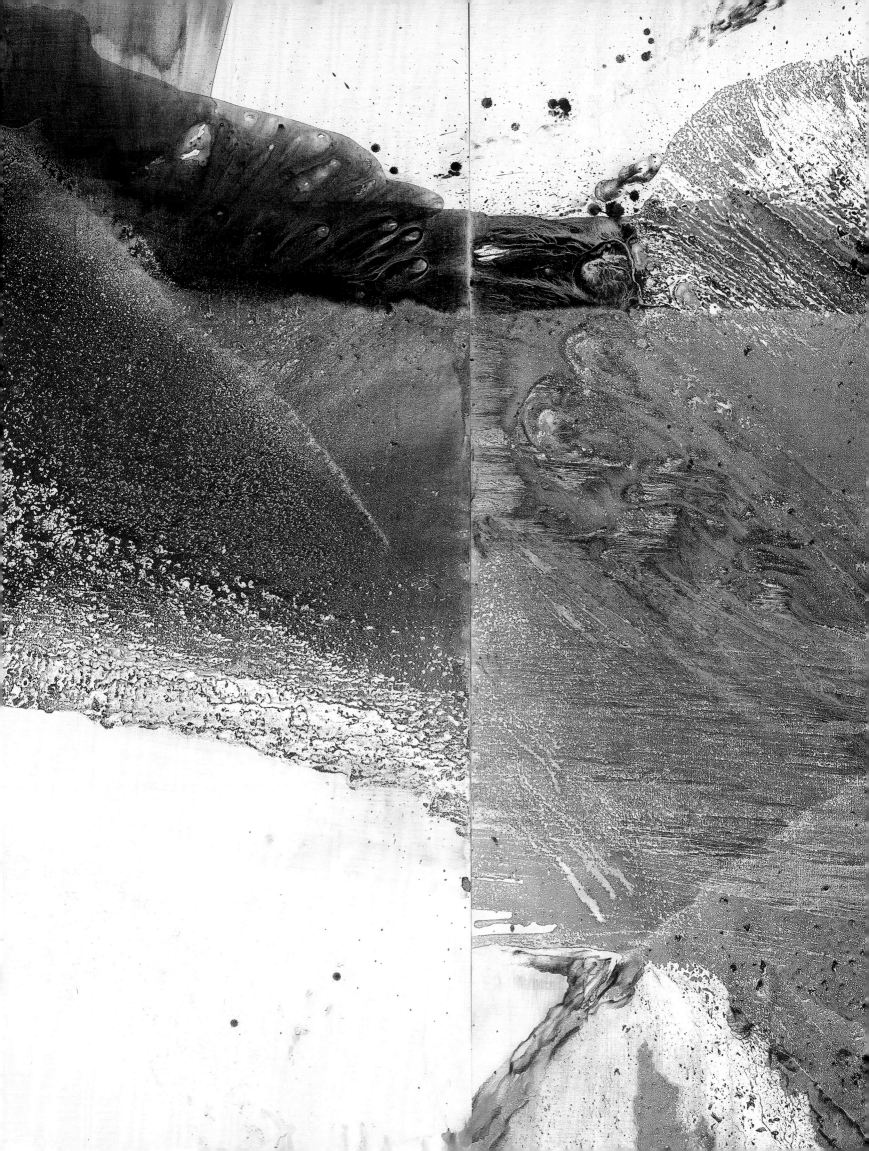

# WANG YAN CHENG

## BIOGRAPHY

Wang Yan Cheng creates dynamic abstract canvases that merge his rigorous traditional training in Chinese painting with the evocative strokes that he gleaned from Western art as a young adult. The eldest of six children, he was born in 1960 in the People's Republic of China. He spent much of his youth in Shandong Province, where his family had relocated after the Maoist Cultural Revolution. His mother, now deceased, managed a hospital and his father was an executive at a petroleum company. In his spare time, his father practiced Chinese calligraphy; Wang Yan Cheng remembers making calligraphy inks for his father as a child. Though he had originally dreamed of being a pilot, it was perhaps this formative artistic experience that encouraged his decision to pursue painting. Despite his mother's reservations about a career in the visual arts, Wang Yan Cheng established himself as a talented representational painter at an early age.

Under the Maoist regime, which promoted opera and theater as the nation's primary art forms, the visual arts were limited to an ideologically mandated Social Realism, a far cry from the gestural, abstract style for which Wang Yan Cheng would later become known. When the Cultural Revolution came to an end after Mao's death in 1976, the visual arts were subject to less stringent government regulations, allowing for more freedom and innovation in the academy. Reflecting upon the decreasing bureaucratic control over the arts at this time, Wang Yan Cheng said, "the situation in China had changed, and I realized that artistic creation required emancipation of myself."[1] He studied at the Shandong School of the Arts from 1978 to 1981, and then at the Shandong Institute of Fine Arts. His professors, many of whom had recently returned from France (after pursuing the tradition of the "Voyage to the West"), encouraged students to copy European old master paintings. He brought this training to Social Realist themes, and at nineteen he was recognized as an accomplished figurative artist when he won a prize for his compelling paintings of daily life in China, which featured subjects such as children playing games and workers relaxing. By 1981, he had won third prize in a national competition of young artists

on the merits of his sketch *Fight of Two Children*, which featured a brawl between two farmers. From 1986–89 he worked as a researcher at the Chinese Central Institute of Fine Arts in Beijing.

In 1989, Wang Yan Cheng traveled to France, embarking on his own "Voyage to the West." Invited by his father's friend, Maxime Bonito, Wang Yan Cheng spent several months living in Saint-Étienne before moving to Paris. He recalled,

> I was broke. I learned the language as fast as I could, but, well, I needed some time. I was lonely, far from my kin… I did odd jobs, like Chinese calligraphy. Since I was good in figurative art, I did commissioned portraits. I tried to imitate Ingres! That allowed me to eke out a living—as well as to continue to paint, to make my own way, to deepen my style, and finally to become myself. [2]

In Paris, he saw artworks that he had studied in China, including those by Nicolas Poussin and Titian, and was inspired by a variety of artists ranging from Paul Cézanne to contemporary painters like Gerhard Richter. Wang Yan Cheng found a profound affinity between the expressionism and lyrical abstraction of twentieth century Western art and the techniques of traditional Chinese painting. With a highly analytical, mathematical approach, Wang Yan Cheng deconstructed seminal works by Cézanne, Pablo Picasso, and Mark Rothko, and soon began to develop his own form of expressionistic abstraction that incorporated both Chinese and Western conventions.

Following in the tradition of established lyrical abstractionists Zao Wou-Ki and Chu Teh-Chun, both of whom had also studied painting in China before moving to France, Wang Yan Cheng used abstraction to bridge Zen practices and analytic thought, translating these philosophies into a unified visual program. His paintings are composed of swirling, calligraphic lines that exist in a delicate balance. His shapes, often thickly impastoed and at other times weightless and nearly transparent, remain abstract while still alluding to landscapes, a genre practiced in Europe, but epitomized by Song Dynasty painting. Like his canvases, his childhood memories are populated with landscapes of vivid colors; Wang Yan Cheng remembers the oil field where his father worked blanketed in the grays of dawn and dusk and the fiery orange hues of sunrise and sunset. In combining his memories from home, his training in Chinese representational painting, and the bold color theories of Western modernism, Wang Yan Cheng developed a form of cosmic abstraction. In his large-scale paintings, he uses color to convey depth without perspective, drawing viewers into the canvas and creating a sensory experience through his use of color.

By the mid-1990s Wang Yan Cheng's work had achieved critical acclaim in Europe, with his painting winning first prize at the Prince Albert of Monaco Foundation in 1996. Though the artist has continued to be the subject of numerous exhibitions in Europe (mainly in France), he maintains strong ties to China. Since 1995 he has been a visiting professor at the Academy of Fine Arts of Shandong, and since 2004 at the Academy of Fine Arts of Shanghai. His work has been acquired by major Chinese muse-

ums including Shandong Art Museum, Guangdong Museum of Art, and the National Art Museum of China, as well as important cultural institutions such as the Opera House in Beijing, the National Center for the Performing Arts in Beijing, and the Chinese Embassy in Paris. He also acted as general secretary of the World Chinese Artists Association in 1996, and then as the official representative of China for the International Association of the Arts at UNESCO in 2002.

Today, Wang Yan Cheng maintains studios in Paris and Beijing. Major solo museum exhibitions were held at the Guangdong Museum of Art (2000) and Musée de Montparnasse, Paris (2010). In 2014, the National Museum of History in Taipei mounted an extensive retrospective on the artist. Wang Yan Cheng was also selected to participate in the Shanghai Museum of Art Biennial (2002), the French Pavilion at the Shanghai World Expo (2010), and the Chinese Pavilion at the Milan International Expo (2015).

1    "Mais la situation a bien changé et j'ai compris que la creation artistique exigeait une emancipation de moi-même."
     In Philippe Monsel, *Wang Yan Cheng* (Paris: Cercle d'Art, 2010), 6.

2    Zong Cheng, *Wang Yan Cheng: Peintures récentes*, translated by André Christen (Paris: Louis Carré & Cie, 2013), 38.
     Originally published in Bernard Vasseur, *Wang Yan Cheng* (Paris: Éditions Cercle d'Art, 2010).

# WANG YAN CHENG

## CHRONOLOGY

| | |
|---|---|
| 1960 | Born in Maoming City, Guangdong Province<br>Ancestral home, Shandong, China |
| 1978–81 | Graduated from the Arts College of Shandong, majored in Fine Arts |
| 1981–85 | Graduated from Oil Painting Department of Shandong University of Arts, B.A |
| 1985–86 | Teaching Assistant, Shandong University of Arts |
| 1986–88 | Studied in Advanced Training Class, Department of Art History, China Academy of Fine Arts, Beijing |
| 1988–89 | Arts Council of Chinese Artists Association;<br>Vice director of the Publicity Department, the 7th National Fine Arts Exhibition |
| 1991–93 | Studied at Université Jean Monnet Saint-Étienne |
| 1992 | Lecturer at Shandong University of Arts |
| 1995 | Visiting Professor at Shandong University of Arts |
| 1996 | Deputy Secretary of Chinese Artists Association |
| 2000 | Member of AIAP, UNESCO |
| 2002 | Vice President of IACA, AIAP, UNESCO |
| 2003 | Vice President of Salon Comparaisons, France |
| 2004–06 | Painter in residence at Diaoyutai State Guesthouse |
| 2006 | Honored Chevalier des Arts et Lettres by French government |
| 2013 | Awarded Legion of Honour by French government |
| 2014 | Awarded SAINT-EMILION "Wine Knight" Medal |
| 2015 | Won the Commander Medal of French Arts and Literature |
| 2018 | Visiting Professor at Accademia di Belle Arti di Roma, Italy |

## SOLO EXHIBITIONS

| | |
|---|---|
| 1993 | Galerie Façade, France |
| 1994 | Galerie Art Service, France |
| | Galerie Gaymu, Paris |
| 1995 | Galerie Jean, France |
| | Galerie de Vieux Lyon, Lyon |
| | Galerie Jens, France |
| | Galerie Mann, France |
| | Art Center of the 14th arrondissement, Paris |
| | Galerie Façade, France |
| 1996 | RIS-ORANGIS Art Center, France |
| | Galerie Fardel, France |
| 1997 | EVIE Municipal Art Center, France |
| | Galerie Rueil Horizon, France |
| 1998 | Galerie du Vieux Lyon, Lyon |
| 1999 | Galerie Fardel, Le Touquet, France |
| | Shenzhen Fine Arts Academy, China |
| | He Xiangning Art Museum, Shenzhen China |
| 2000 | Guangdong Museum of Art, China |
| | Shenzhen Art Museum, China |
| | Galerie Dukan, Marseille |
| 2001 | Galerie Lacroix, La Rochelle, France |
| | Galerie Serignan, Avignon |
| 2002 | Galerie Rouse, France |
| | Galerie du Vieux Lyon, Lyon |
| 2003 | Galerie Protée, Paris |
| | Art Paris, France |
| | Sponsored by Le Groupe Dassault, France |
| 2005 | Galerie des Tuiliers, Lyon |
| | China Cultural Center, Paris |
| | Assurances Générales de France (AGH) |
| 2006 | Galerie Protée, France |
| | Art Paris, France |
| | Galerie des Tuiliers, Lyon |
| 2007 | Galerie Protée, Paris |
| | Galerie des Tuiliers, Lyon |
| | Galerie Patrice Trigano, Paris |
| 2008 | Galerie Protée, Paris |
| | Galerie Patrice Trigano, Paris |
| | Galerie des Tuiliers, Lyon |

| 2009 | Galerie Patrice Trigano, Paris |
| | Galerie des Tuiliers, Lyon |
| | Chateaux Saint Pierre et Gloria, Bordeaux |
| 2009–10 | Galerie des Tuiliers, Lyon |
| 2010 | Louis Aragon Art Center, France |
| | Galerie "The Peak Suite," Hong Kong |
| | Exposition Le Musée du Montparnasse, Paris |
| | French Pavilion of Shanghai World Expo, China |
| 2011 | Galerie Louis Carré & Cie, Paris |
| 2014 | Galerie Louis Carré & Cie, Paris |
| | Saint-Million, France |
| | The National Museum of History, Taipei |
| 2015 | Musée des Arts Asiatiques, Nice |
| 2017 | China Art Academy, Beijing |
| 2018 | Accademia di Belle Arti di Roma, Rome |

## GROUP EXHIBITIONS

| 1980 | The Second National Young Artists' Exhibition, National Art Museum of China, Beijing |
| | Chinese Oil Painting Exhibition, Austria, sponsored by Chinese Ministry of Culture |
| 1982 | Chinese Youth Painting in Progress |
| 1985 | Chinese Oil Painting Exhibition in Europe, sponsored by Chinese Ministry of Culture |
| | Chinese Oil Painting Exhibition in Japan |
| 1986 | 1st National Exhibition of Oil Paintings, Shanghai, China |
| | 7th National Fine Arts Exhibition |
| 1989 | China's First Modern Art Fine Arts Exhibition |
| 1991 | Scene Painting, Mussolini en hiver, France |
| | Group Exhibition, Galerie Façade, France |
| 1992 | Group Exhibition, Galerie Jean, France |
| | Group Exhibition, Galerie Art Service, France |
| 1993 | Group Exhibition, Galerie Gaymu, France |
| | Ris-Orangis Salon, France |
| 1994 | Group Exhibition, Galerie Catherine Guérard, France |
| | Group Exhibition, Galerie Gaymu, Paris |
| 1995 | Chinese Modern Art, Benedictine Palace, Fecamp, France |
| | Today's Salon for Great Young Artists |
| | Group Exhibition, Free Space |
| | Modern Art Exhibition, Eguilly Bourgogne Castle, France |
| | Modern Art Exhibition, Château d'Artigny, Montbazon, France |
| | Modern Art Exhibition, sponsored by Monaco Prince Art Foundation Monaco |

| 1996 | French Art Exhibition, Cracovie Palace, France |
| | Chinese Art Exhibition |
| | Group Exhibition, Galerie Suzanne Tarasieve, Paris |
| | Barbizon Salon Exhibition |
| | Art Collection Exhibition, Pierre Cardin Center |
| | Portrait Exhibition, French Cultural Academy |
| | Salon d'Automne, Paris |
| | Group Exhibition, Galerie Mann, France |
| 1997 | Modern Art of China, Paris |
| | Group Exhibition, Galerie Rueil Horizon, France |
| | Group Exhibition, Galerie du Vieux Lyon, Lyon |
| 1998 | Shandong Art Museum |
| | France-Japan Art Exchange Exhibition |
| | Group Exhibition, Galerie Colette, Paris |
| | French Parliament Art Salon Exhibition |
| 1999 | Group Exhibition, Galerie Temoine, France |
| 2000 | Modern Art Exhibition, Luxembourg |
| | The 20th Century Chinese Oil Painting Exhibition, Beijing |
| 2001 | Yanhuang Grand Art Exhibition of China |
| | Pierre Cardin Art Space |
| | Group Exhibition, Galerie Dukan, France |
| 2002 | Group Exhibition, Galerie Sanguine La Rochelle, France |
| | Group Exhibition, Galerie Serignan, Avignon |
| | Biennial Art Exhibition, Shanghai Museum of Art |
| | Group Exhibition, Galerie du Vieux Lyon, Lyon |
| | Guangdong Museum of Art, China |
| | AIAP |
| | Asia Art Center, Taipei, Republic of China |
| | BEMARS Fine Arts Exhibition, Germany |
| | Group Exhibition, Galerie Protée, Paris |
| | Salon d'Automne, Paris |
| 2003 | International Art Exhibition, the United Nations, Geneva |
| | Group Exhibition, Galerie Protée, Paris |
| 2004 | Salon de Comparaisons, France |
| | Group Exhibition, Galerie Protée, Paris |
| 2005 | Ris-Orangis Municipal Art Center |
| | Salon de Comparaisons, France |
| 2006 | Group Exhibition, Galerie Protée, France |
| | Group Exhibition, Galerie des Tuiliers, France |
| | Group Exhibition, Galerie Patrice Trigano, France |
| 2007 | Salon de Comparaisons, France |
| 2008 | Group Exhibition, Galerie Protée, France |
| | Group Exhibition, Galerie Patrice Trigano, Paris |
| | Group Exhibition, Galerie des Tuiliers, Lyon |
| 2009 | Salon de Comparaisons, Paris |
| 2011 | Contemporary Art of the Artists from Shandong, Chinese Cultural & Art Center |
| | Salon de Comparaisons, the Grand Palais in Paris |
| 2012 | Salon de Comparaisons, the Grand Palais in Paris |
| 2013 | Salon de Comparaisons, the Grand Palais in Paris |
| 2015 | Oil Painting Exhibition of Shandong Artists, Shandong Art Museum |
| | Milan International Expo, Chinese Pavilion |

**2016**  Zhang Hongxiang and his students, Jinan Art Museum
Chinese Contemporary painters from Shandong, Shandong Art Museum
New Yimeng Art Exhibition, Shandong Art Museum
New Yimeng Art Exhibition, Today Art Museum
Salon de Comparaisons, the Grand Palais in Paris
**2017**  Foundation Taylor
**2019**  The Opened Window Greets the Beauty-Award Exhibition Celebrating the 70th Anniversary of the Founding of New China and the 40th Anniversary of the Founding of Shenzhen, National Art Museum of China, Beijing
The 60th Anniversary of the Founding of Shandong University of Arts, Shandong Art Museum
ENERGY- Exhibition of Shandong Province Artistic Development Achieved in the Past 40 Years of Reform and Opening Up, National Art Museum of China, Beijing

## PUBLICATIONS

**2000**  Wang Yan Cheng's Selected Oil Paintings
**2004**  Paris, Galerie Protée, Wang Yan Cheng's Oil Paintings Collection
**2005**  Paris, Galerie Protée, Wang Yan Cheng's Oil Paintings Collection
**2006**  Fifty Chinese Oil Painting Artists: Wang Yan Cheng
**2007**  France, Cercle d'Art Publishing House, Wang Yan Cheng's Oil Paintings Collection
**2008**  China, People's Fine Arts Publishing House, Wang Yan Cheng's Oil Paintings Collection
**2010**  Art Museum of Montparnasse, Wang Yan Cheng's Oil Paintings Collection
Press of France, Centennial Collection: Wang Yan Cheng's Oil Paintings

## COLLECTIONS & HONORS

**1981**  3rd Prize of the 2nd Young Artists' Exhibition of China
**1982**  1st Prize of 1st Youth Oil Painting Exhibition of Shandong
*A Walk in the Time*, won the prize of Monaco Prince Art Foundation
**1996**  Art Studio, 1st Prize of Ries Salon, work acquired by Ries Municipal Government
*Distance Light* acquired by the Grand Art Autumn Salon Exhibition, France
**1997**  *The Blue Memories* wins the Prize of Autumn Salon Exhibition, France
**1999**  *Space-time* acquired by Qingdao Municipal Museum
*Sunrise* wins the prize of Excellent works, The Grand Exhibition of Chinese Art
Two of his paintings acquired by Shenzhen Art Museum
*Untitled* acquired by Shenzhen Art Academy
*Melody of Autumn* acquired by Guangdong Museum of Art
*Composition* acquired by He Xiangning Art Museum
**2000**  *Distance Light* acquired by National Art Museum of China
**2001**  *A Flush of Red*, Silver Prize of Yanhuang Art Exhibition of China
**2002**  *Untitled* acquired by Shandong Art Museum
*Untitled* acquired by Anting New Town, Shanghai
**2003**  *Water* acquired by United Nations, Geneva
*Untitled* acquired by Le Groupe Dassault
**2004**  *Melody of Camouflage* acquired by PLA Theatre
**2006**  *Lingering Mood* acquired by Chinese Embassy in Paris and presented to the Prime Minister of France
**2004–06**  Nine paintings acquired by Diaoyutai State Guesthouse
**2008**  *Sound of Nature*, large oil painting, acquired by National Centre for the Performing Arts

年表

祖籍山东，1960.1.9 生于广东省茂名

| | | | |
|---|---|---|---|
| **1978–81** | 毕业于山东省艺术专科学校美术专业 | | |
| **1981–85** | 毕业于山东省艺术学院美术系油画专业获学士学位 | | |
| **1985–86** | 山东省艺术学院助教 | | |
| **1986–88** | 中央美术学院艺术史论系高研班 | | |
| **1988–89** | 中国美术家协会艺委会工作，任全国第七届美展宣传部副主任 | | |
| **1991–93** | 法国圣太田造型艺术大学学习 | | |
| **1992** | 被聘为山东省艺术学院讲师 | | |
| **1995** | 山东省艺术学院客座教授 | | |
| **1996** | 华人艺术家协会副秘书长 | | |
| **2000** | 联合国教科文国际造型协会AIAP成员 | | |
| **2002** | 联合国教科文组织国际造型协会国际艺术中心IACA副主席 | | |
| **2003** | 法国国家比较沙龙副主席 | | |
| **2004–06** | 三年期间应钓鱼台国宾馆之邀为国宾馆作画 | | |
| **2006** | 获法国国家文化骑士勋章 | | |
| **2013** | 获法国国家文化军团军官勋章 | | |
| **2014** | 获SAINT–EMILION市酒骑士勋章 | | |
| **2015** | 获法国国家文化司令官勋章 | | |
| **2018** | 意大利罗马美术馆学院客座教授 | | |

**个展**

| | |
|---|---|
| **1993** | 法国Galerie Facade画廊 |
| **1994** | 法国Galerie Art Service画廊 |
| | 法国Galerie Gaymu画廊 |
| **1995** | 法国Galerie Jean画廊 |
| | 法国Galerie du Vieux Lyon画廊 |
| | 法国Galerie Jens画廊 |
| | 法国Galerie Mann画廊 |
| | 法国巴黎14区艺术中心 |
| | 法国Galerie Facade画廊 |
| **1996** | 法国RIS-ORANGIS艺术中心 |
| | 法国Galerie Fardel画廊 |
| **1997** | 法国EVIE市政府艺术中心 |
| | 法国Galerie Rueil Horizon画廊 |
| **1998** | 法国Galerie du Vieux Lyon画廊 |
| **1999** | 法国Galerie Fardel画廊 |
| | 深圳画院 |
| | 深圳何香凝美术馆 |
| **2000** | 广东省美术馆 |
| | 深圳美术馆 |
| | 法国马赛Galerie Dukan画廊 |
| **2001** | 法国Galerie Lacroix, La Rochelle画廊 |
| | 法国Galerie Serignan画廊 |
| **2002** | 法国Galerie Rouse画廊 |
| | 法国Galerie du Vieux Lyon画廊 |
| **2003** | 法国Galerie Protee画廊 |
| | 法国巴黎国际艺术博览会Art Paris |
| | 法国达索航空集团 |
| **2005** | 法国Galerie des Tuiliers画廊（里昂） |
| | 中国驻法国文化中心 |
| | 法国AGF集团 |
| **2006** | 法国Galerie Protee画廊 |
| | 法国巴黎国际艺术博览会Art Paris |
| | 法国Galerie des Tuiliers画廊 |
| **2007** | 法国Galerie Protee画廊 |
| | 法国Galerie des Tuiliers画廊 |
| | 法国Galerie Patrice Trigano画廊 |
| **2008** | 法国Galerie Protee画廊 |
| | 法国Galerie Patrice Trigano画廊 |
| | 法国里昂Galerie des Tuiliers画廊 |

| | | | |
|---|---|---|---|
| **2009** | 法国 Galerie Patrice Trigano 画廊 | **1998** | 山东省美术馆 |
| | 法国里昂 Galerie des Tuiliers 画廊 | | 法日艺术交流展 |
| | 法国波尔多 Chateaux Saint Pierre et Gloria | | 法国 Galerie COLETTE 画展 |
| **2009–10** | 法国里昂 Galerie des Tuiliers 画廊 | | 法国国会艺术沙龙展 |
| **2010** | LOUIS ARAGON 艺术中心 | **1999** | 法国 Galerie TEMOINE 画展 |
| | 香港 GALERIE "THE PEAK SUITE" 画廊 | **2000** | 卢森堡现代艺术展 |
| | 巴黎蒙巴纳斯美术馆 | | 中国 20 世纪油画展 |
| | 上海世博会法国大区馆 | **2001** | 中国炎黄艺术大展 |
| **2011** | 法国 Galerie Louis Carre & Cie 画廊 | | 皮尔.卡丹艺术空间 |
| **2014** | 法国 Galerie Louis Carre & Cie 画廊 | | 法国 Galerie DUKAN 画展 |
| | 法国 Saint-Million | **2002** | 法国 Galerie SANGUINE, La Rochelle 画展 |
| | 台湾台北历史博物馆 | | 法国 Galerie SERIGNA 画展 |
| **2015** | 激情的抽象（尼斯亚洲艺术博物馆） | | 上海美术馆, 双年展系列活动 |
| **2017** | 衍–王衍成艺术展（中国美术馆） | | 法国 Galerie du Vieux Lyon 画展 |
| **2018** | 意大利罗马美术学院 | | 广东省美术馆 |
| | | | 五大洲艺术展 AIAP |
| | | | 台湾亚洲艺术中心 |
| **联展** | | | 德国 BEMARS 美术展 |
| | | | 法国 Galerie Protee 画展 |
| **1980** | 全国第二届青年美展 | | 法国秋季沙龙艺术展 |
| | 文化部组织去奥地利中国油画展 | **2003** | 联合国日内瓦国际艺术展 |
| **1982** | 前进中的中国青年画展 | | 法国 Galerie Protee 画展 |
| **1985** | 文化部组织旅欧油画展 | **2004** | 法国比较沙龙艺术展 |
| | 中国油画展赴日展 | | 法国 Galerie Protee 画展 |
| **1986** | 中国首届油画展 | **2005** | 法国 Ris-Orangis 市艺术中心展 |
| | 全国第七届美展 | | 法国比较沙龙艺术展 |
| **1989** | 中国首届现代艺术展 | **2006** | 法国 Galerie Protee 画展 |
| **1991** | 法国 Mussolini en hiver 布景制作 | | 法国 Galerie des Tuiliers 画展 |
| | 法国 Galerie Farcade 画展 | | 法国 Galerie Patrice Trigano 画展 |
| **1992** | 法国 Galerie Jean 画展 | **2007** | 法国比较沙龙艺术展 |
| | 法国 Galerie Art Service 画展 | **2008** | 法国 Galerie Protee 画展 |
| **1993** | 法国 Galerie Gaymu 画展 | | 法国 Galerie Patrice Trigano 画展 |
| | 法国里斯沙龙 | | 法国 Galerie des Tuiliers, Lyon 艺术展 |
| **1994** | 法国 Gatherine Guerard 画展 | **2009** | 法国比较沙龙艺术展 |
| | 法国 Galerie Gaymu 画展 | **2011** | 山东人当代艺术展（法国巴黎中国文化艺术中心） |
| **1995** | Fecamp Benedictine 皇宫中国现代艺术展 | | 法国比较沙龙展（巴黎大皇宫） |
| | 伟大的年青的今天沙龙 | **2012** | 法国比较沙龙展（巴黎大皇宫） |
| | 白由空间画廊展 | **2013** | 法国比较沙龙展（巴黎大皇宫） |
| | 法国 Eguilly Bourgogne 古堡现代画展 | **2014** | Art Paris 大皇宫巴黎艺术展 |
| | 法国 Artigny 古堡现代画展 | **2015** | 山东油画作品展（山东省美术馆） |
| | 摩纳哥王子艺术基金会现代艺术展 | | 意大利米兰世博会 |
| **1996** | Cracovie 皇宫法国艺术展 | **2016** | 张洪祥师生展（山东济南美术馆） |
| | 中国艺术大展 | | 中国当代山东籍著名画家作品展（山东美术馆） |
| | 法国 Galerie Suzanne Trazieve 画展 | | 新沂蒙美术作品展（山东美术馆） |
| | 巴比松沙龙展 | | 新沂蒙美术作品展（今日美术馆） |
| | 法国皮尔.卡丹中心收藏艺术展 | | Salon Comparaisons 比较沙龙艺术展 大皇宫巴黎 |
| | 法兰西文化院肖像画展 | **2017** | 法国泰勒基金会（FONDATION TAYLOR） |
| | 法国秋季沙龙展 | **2019** | 打开的窗口是美丽的一倾注新中国成立 70 周年暨深圳建市 40 周年 |
| | 法国 Galerie MANN 画展 | | 美术作品展（中国美术馆） |
| **1997** | 巴黎中国现代艺术展 | | 山东艺术学院建校 60 周年美术作品展（山东美术馆） |
| | 法国 Galerie Rueil Horizon 画展 | | 能量一改革开放 40 年山东美术发展成果展（中国美术馆） |
| | 法国 Galerie du Vieux Lyon 画展 | | |

## 出版

**2000**　《王衍成油画选》
**2004**　《Wang yancheng油画集》Galerie Protee
**2005**　《Wang yancheng油画集》Galerie Protee
**2006**　《中国油画50家王衍成》
**2007**　《Wang yancheng油画集》法国CERCLE D' ART出版社
**2008**　《王衍成油画选》人民美术出版社
**2010**　《Wang yancheng画集》蒙巴纳斯美术馆发行
　　　　《世纪收藏王衍成油画集》法国出版社

## 收藏与获奖

**1981**　中国第二届全国青年美展三等奖
**1982**　山东省首届青年油画展一等奖
　　　　作品《时间的漫步》获摩纳哥王子艺术基金会大奖
**1996**　作品《画室》收藏于法国里斯市政府并获得里斯沙龙一等奖
　　　　作品《远光》在华夏艺术大展中获奖并收藏
**1997**　作品《蓝色的回忆》获法国秋季沙龙奖
**1999**　作品《时空》收藏于青岛博物馆
　　　　作品《日出》获中国艺术大展优秀作品奖
　　　　两幅作品收藏于深圳美术馆
　　　　作品《无题》收藏于深圳画院
　　　　作品《秋韵》收藏于广东省美术馆
　　　　作品《构成》收藏于深圳何香凝美术馆
**2000**　作品《远光》收藏于中国美术馆
**2001**　作品《一抹红晕》获中国炎黄艺术大展银奖
**2002**　作品《无题》收藏于山东省美术馆
　　　　作品《无题》收藏于上海安亭新镇
**2003**　作品《水》收藏于联合国日内瓦宣传部
　　　　作品《无题》收藏于法国达索航空集团
**2004**　作品《迷彩的旋律》被解放军歌剧院收藏
**2006**　作品《情思》中国驻法国使馆赠送于法国总理收藏
**2004-06**　9幅作品收藏于钓鱼台国宾馆
**2008**　天籁之音》巨幅油画收藏于国家大剧院

## PHOTO CREDITS  |  图片版权

Pages 8–9 and 32–33
Photos of Wang Yan Cheng in his Paris studio, 2013.

Pages 6, 26–27 and 78
Photos of Wang Yan Cheng in his Beijing studio, 2019.

Pages 34–35 and 76–77
Details of *Untitled (Triptych)*, 2019
oil on canvas in three panels  |  82 $^{5}$/8 × 307 inches (210 × 780 cm), each panel 82 $^{5}$/8 × 102 inches (210 × 260 cm)

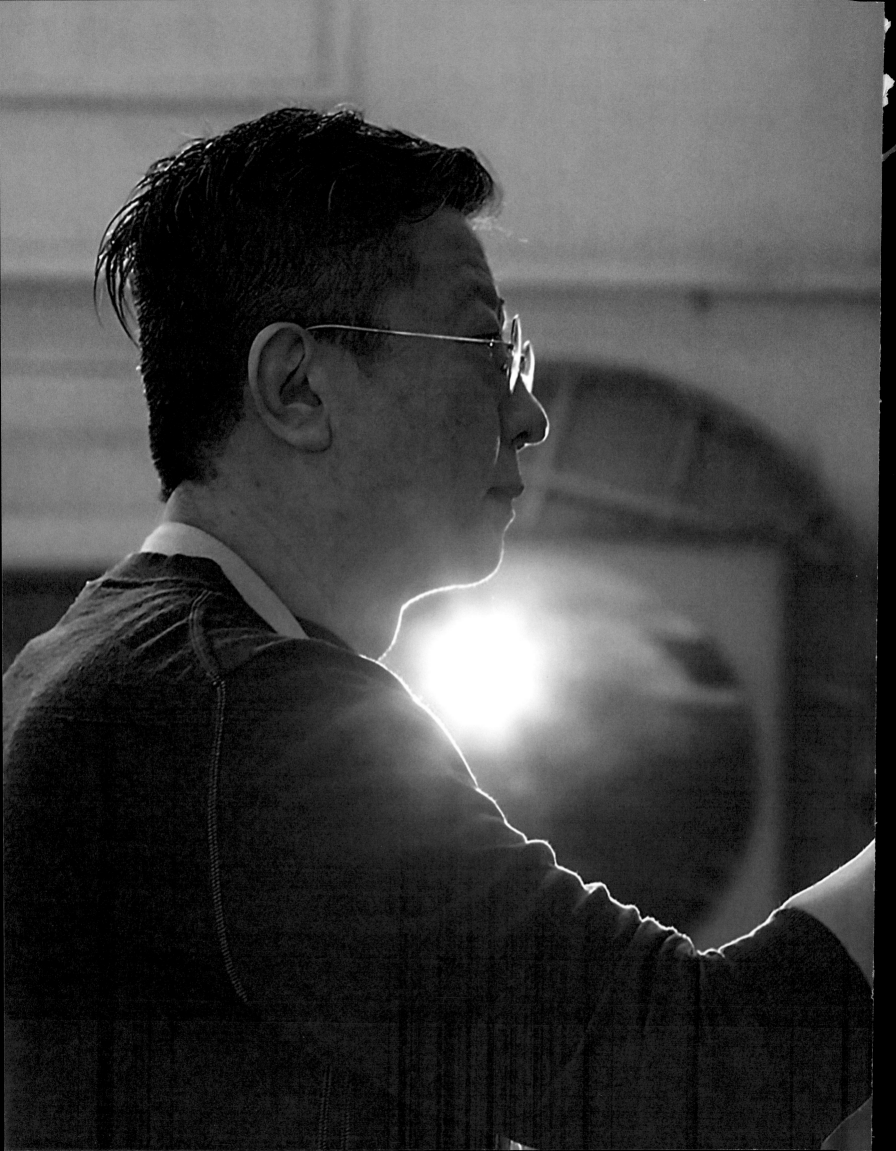